THE COMPLETE GUIDE TO ALTERED IMAGERY

QUARRY

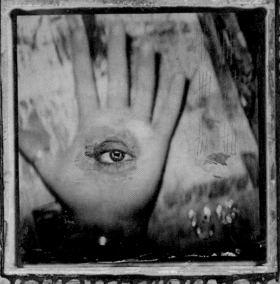

THE COMPLETE GUIDE TO ALTERED IMAGERY

MIXED-MEDIA TECHNIQUES FOR COLLAGE,
ALTERED BOOKS, ARTISTS JOURNALS, AND MORE

QUARRY BOOKS

KAREN MICHEL

First published in the United States of America by
Quarry Books, a member of
Quayside Publishing Group
33 Commercial Street
Gloucester, Massachusetts 01930-5089
Telephone: (978) 282-9590
Fax: (978) 283-2742
www.rockpub.com

Library of Congress Cataloging-in-Publication Data
Michel, Karen.
 The complete guide to altered imagery : for collage, altered books, artists journals, and more / Karen Michel.
 p. cm.
 ISBN 1-59253-177-6 (pbk.)
 1. Decalcomania. 2. Polaroid transfers. 3. Photographs—Coloring. 4. Photography, Handworked. 5. Transfer-printing. 6. Collage. 7. Altered books. I. Title.
 TT880.M53 2005
 702'.81'2—dc22 2005004970
 CIP

ISBN 1-59253-177-6

10 9 8 7 6 5 4 3 2

Design: Yee Design
Cover Images: Allan Penn

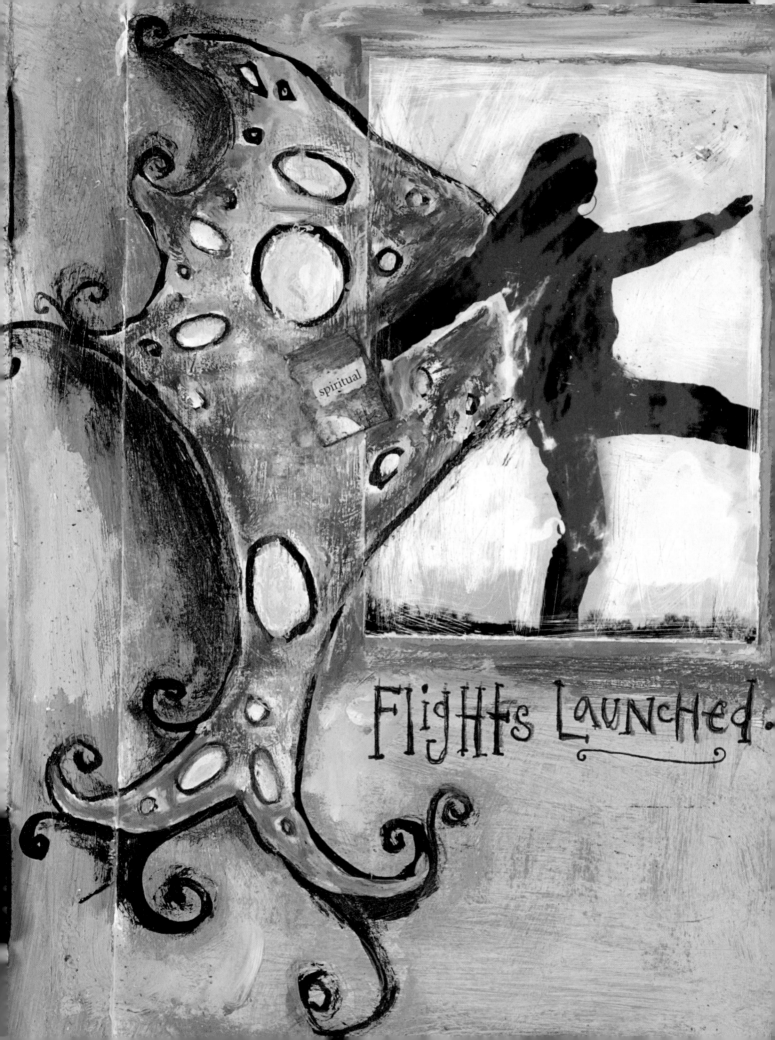

CONTENTS

ALTERED *v.* *To make otherwise; to change in some respect, either partially or wholly; to vary; to modify.*

IMAGERY *n.* *The work of one who makes images or visible representation of objects.*

INTRODUCTION

OUR LIVES ARE FILLED WITH IMAGERY. Many of us have collections of images all around us. Photographs, old postcards, magazine pages that we've saved—the list goes on. All of these images, perfect or imperfect, are rife with creative possibilities. They are the raw materials that can be reimagined, enhanced, and transformed into wonderful elements to use in our artwork.

Creating altered imagery is a process that can be explored by using mixed-media collage techniques, alternative photography processes, printmaking methods, and more. It is a realm where the golden rule is "anything goes," and personal exploration and experimentation are the keys to success.

Working with altered imagery can be a way of examining our environment, our surroundings, and how we relate to them. You get to play the role of storyteller, telling your tale from *your* point of view using the universal visual language of imagery, which can transcend words. Sound magical? It can be.

Consider the process of altering a surface as an act of leaving your mark, investigating life's elements by reinterpreting bits and pieces of everyday adventures. Or, simply consider the process as creative playtime. As our self-expression becomes more fluid, self-awareness and increased confidence build creative strength, and thus lead us to bigger and better artistic adventures.

So go ahead and study life's ordinary or extraordinary moments. Preserve and reinterpret your memories and personal discoveries. Leave evidence of your creative play. Unearth your inner magician, and don't be afraid to get your hands dirty!

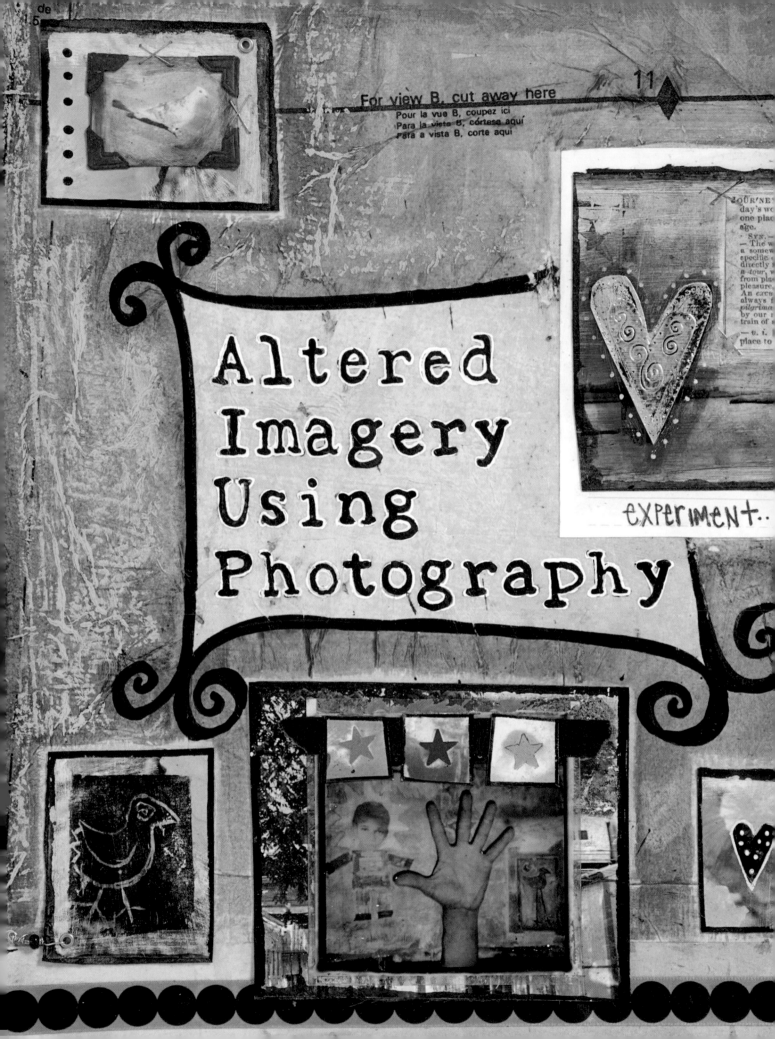

For view B, cut away here
Pour la vue B, coupez ici
Para la vista B, córtese aquí
Para a vista B, corte aqui

11

Altered Imagery Using Photography

experiment...

CHAPTER 1:
ALTERED IMAGERY USING PHOTOGRAPHY

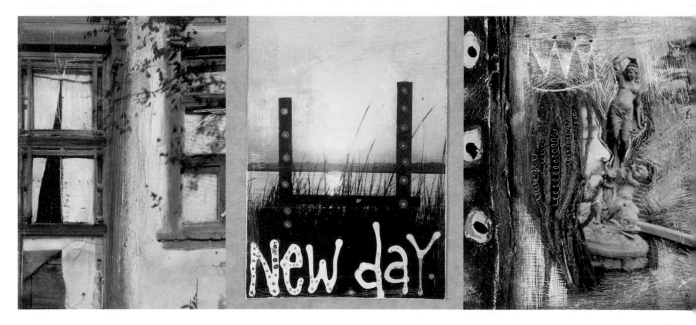

Most of us have boxes full of old photographs from past vacations, family parties, and photographic adventures. Whereas the lucky photographs make it into albums, most find permanent homes in boxes under beds or deep within closets.

Using our own imagery in our work gives it personal meaning. Every photograph represents a part of our personal history: places we have been or people we have known and who are special in our life. Rather than using a picture of a stranger cut from a magazine, we can include one of a friend or family member and merge memory with our art.

Using Sandpaper and an Awl

This photograph was altered using sandpaper to rub away sections of the background and an awl to scratch around areas of the text to create emphasis on the words.

ALTERING 35MM PHOTOGRAPHY
SANDPAPER AND MARK MAKING

Sometimes, the best results can be achieved with the simplest of materials. An image that is worn or distressed tells a story, as if the image has its own personal history.

To distress a photograph, dip it into a pan of lukewarm water just long enough to wet the entire photograph (about 30 seconds), and then remove it. Place the image on a flat surface, and, using fine-grit sandpaper, begin to sand away the edges of the image into the emulsion. If you would like to remove specific areas of the photograph, gently sand them away while the photo is still damp.

Adding Fine Details
Sandpaper and mark-making tools—in this case, an awl and a sewing needle—were used to alter this photograph.

TIPS

Using a bookbinding awl or any other tool with a sharp point, you can accentuate the form of an image by outlining it and scratching away the surrounding area.

For a more "authentically aged" effect, consider placing the image facedown on the sidewalk or on concrete and applying pressure to the areas you want to mark, as you move it around.

You may need to re-dip your photograph in water to eliminate the bits of emulsion left on the photograph's surface from the sanding process.

Materials
- photograph
- pan of lukewarm water
- fine-grit sandpaper
- awl
- sewing needle

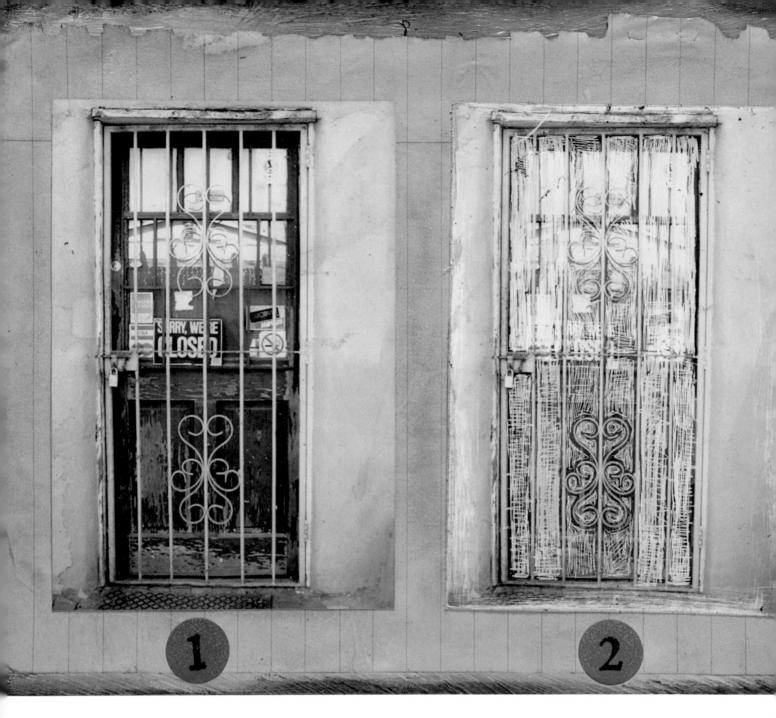

Materials

- photographs
- watercolor paints
- fine-grit sandpaper
- scissors
- plastic rubbing plates

Before and After Sanding and Scraping

Photograph 1: Note that the area inside the door's filigree is quite busy and intricate. Altering this area will require a finer tool than sandpaper, such as an awl or even a small Phillips head screwdriver.

Photograph 2: The edges of the photograph have been sanded down, and the inner areas of the door's filigree have been removed with an awl. This image is now ready for further altering with paints and markers.

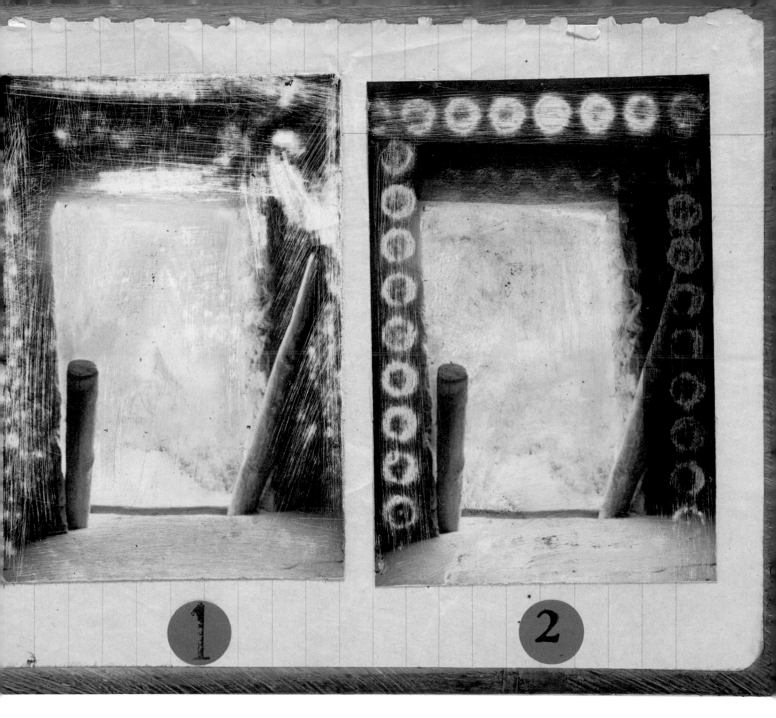

Using Bold Markers and Rubbing Plates

Photograph 1: Here, the edges have been sanded away, exposing the yellow beneath the dark areas of the photographic emulsion. The top-right area has been shaved away with the edge of a scissor blade, creating bolder markings in the surface.

Photograph 2: Plastic rubbing plates were placed under the photograph before it was sanded. Plastic rubbing plates come in various textures and can be an additional fun element to add to your work. Traditionally, you would use the rubbing plates by placing paper over the top of one and rubbing the paper with crayons to transfer designs and patterns. In this case, we will be using our photographs in place of the paper and sandpaper in place of the crayon. Sanding allows the textures of the underlying plate (or object) to show though. Any textured surface—keys, coins, and even textured fabric—will create interesting marks.

Watercolor paints have been used within the windows in both photographs to add much-needed color.

WATERCOLORS, PAINTS, AND MARKERS

Paints, markers, and gel pens can give a photograph new life and character. Water-based markers are great for filling in specific areas with color, such as making grass greener or a dull sky bluer. The advantage of using water-based markers and paints is that they blend well with each other on the photograph's surface. Use them as is or with additional water from a paintbrush.

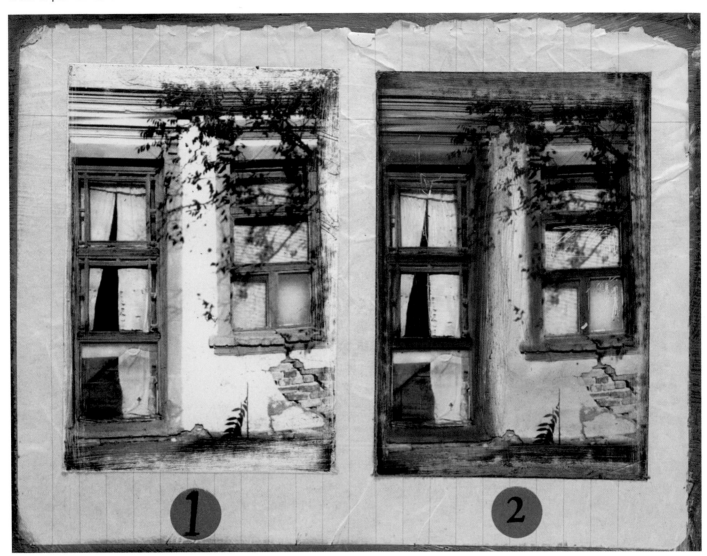

Using Markers for a Vivid Effect

Photograph 1: This photograph is a perfect candidate to which to add color because it has a lot of white, washed-out areas. It has been prepared by having its edges sanded down.

Photograph 2: The pale areas and sanded edges of the photograph have been filled in with water-based markers. Areas within the windows have been reworked and scratched into with an awl to create highlights.

Materials
- photograph
- water-based markers
- awl

 TIP *When using markers or liquid watercolors on your photograph, the surface should be damp but not wet. A little dampness gives you an extra moment to blend the colors. If it's too wet, however, you won't have as much control.*

TIPS

For finer details and more refined edges, try gel pens or pigment pens. Concentrated liquid watercolors are perfect for filling in large areas or for giving the whole picture a full wash of color.

Peerless Transparent Watercolor sheets are a wonderful material for adding color to your photographs. They come in color books containing sheets of paper saturated with highly concentrated transparent dyes in intense colors that can be applied using a paintbrush or cotton swab. To use the color sheets, simply wet your paintbrush and dab it onto the sheet to pick up the paint, then apply it to your photo. When the color dries it becomes part of the emulsion.

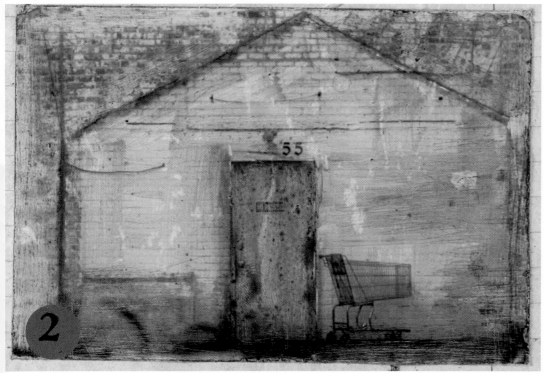

Using Watercolor Paints for a Warm Glow

Photograph 1: Mostly white, this photograph is another good candidate to which to add color. The surface has been prepared by having the edges, as well as parts of the image, sanded down.

Photograph 2: Notice how watercolors have been used to accentuate the shapes within the image. Because watercolor paints are translucent, the sanded areas peek through, creating an interesting surface texture.

Materials

- photograph
- watercolor paints
- sandpaper
- paintbrush

Using Gel Pens for Detail and for Opaque Color ➡

A great tool for creating detailed drawings on the surface of a photograph, gel pens provide fine, opaque lines of color. Here, the basic and detailed features of the face and the outlines of the body have been embellished with gel pens. Gel pens take a bit longer to dry than markers, making it possible to shade in selected areas by using your fingertips to blend together the colors.

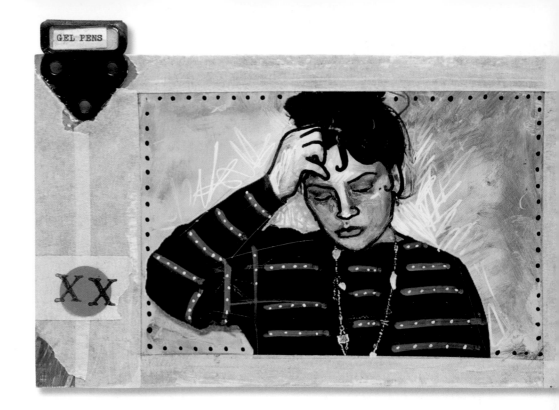

Materials
• photograph
• gel pens

Combining Gel Pens with Markers ➡

Have some fun with your old baby pictures! In this photograph, gel pens were used to draw in a new "hairdo," and water-based markers were used to color in the clothes and background colors. A black border around the photograph contains bold colors and nicely frames the image.

Materials
• photograph
• gel pens
• water-based markers

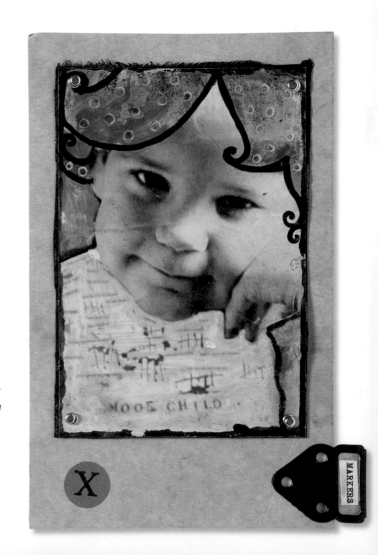

TIP *To ensure brilliant, opaque results when using gel or pigment pens, be sure the surface of the photograph is dry.*

COLLAGE AND STAMPING

Adding stamped images and collage elements to your photograph can add interest to your composition. Soft gel medium is a good adhesive for attaching your collage bits to the surface. When stamping, be sure the photograph's surface is dry, then ink up your stamp and stamp directly on the photo. Any type of inkpad will do, whether it contains pigment- or dye-based inkpad. Or you can even use your water-soluble markers to add color to the back of your stamp.

← Altered Photos in Altered Books

In this altered book, the cover was cut out to function as a frame for the photograph. The photograph was altered using sandpaper, an awl, and markers to add further definition and texture, and glued into the book using gel medium. The book cover was painted using acrylic paints and embellished along the edges with silver brads.

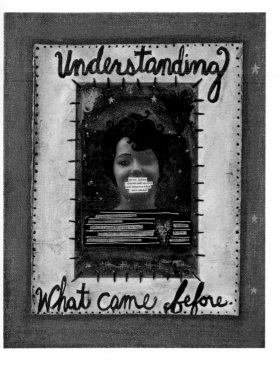

← Combining Several Effects

This old photograph of my mother as a teenager did not have much contrast. To solve some of the contrast issues, her hair and shirt were redrawn using gel pens and markers, and the background was filled in using watercolor paints. Bits of collaged words were adhered over her mouth and the stripes in her shirt. A heart was created with glitter and added to the surface. The finished photograph was sewn to a paper background that was prepared with paints and gel markers to create an alternative frame.

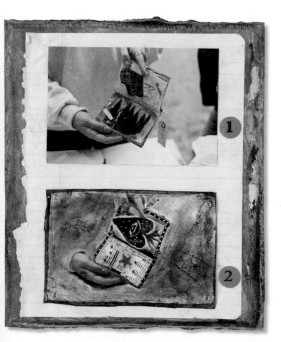

← Re-creating a Background

Photograph 1: This image has a workable subject, but the background elements do not complement it.

Photograph 2: This is the same image with the background sanded away and painted. The images within the book are both stamped and collaged, redefining the subject matter.

Materials

- photograph
- gel pens
- water-based markers
- watercolor paints
- rubber stamps
- rubber-stamp ink (dye or pigment)
- collage elements
- glitter
- fine-grit sandpaper
- paintbrush

Altering the Photograph with Chemicals

By using common household products, you can alter the surface of 35mm photographs in unique and unusual ways.

Note: *Be sure to wear rubber gloves and work in a well-ventilated area when working with chemicals.*

USING BLEACH

Altering 35mm prints with bleach can produce seemingly magical results. Bleach removes the top (cyan) layer of color, exposing the magenta and yellow layers below.

Fill a shallow pan wide enough to fit your photograph with water. Fill another with a solution of 50 percent water and 50 percent bleach. Dip the photograph first in the plain water, then into the bleach mixture. When the colors on the surface of the photograph begin changing, rinse it immediately in the plain water. Timing is everything with this process, so be sure to work quickly. To bleach out particular areas of your photo, use a paintbrush with synthetic bristles and apply the bleach mixture to your photo, rinsing it once the desired effect is achieved.

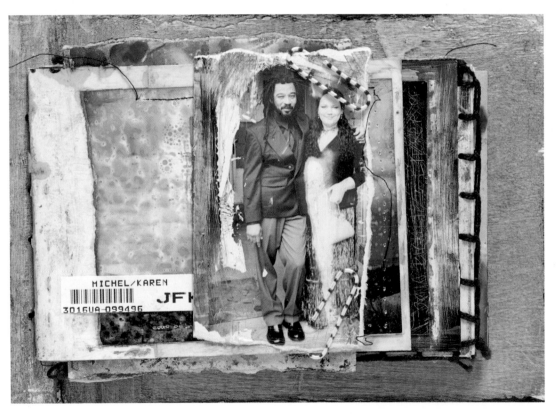

TIPS

Bleaching works best on darker photographs or photographs with dark areas. Photographs that are very light in color or that contain a lot of white should be hand-colored rather than bleached.

If your photograph turns white during the bleaching process, all of the emulsion was removed and you will need to work more quickly when altering future photographs.

Materials
- photograph
- shallow pan
- solution of 50 percent bleach and 50 percent water
- paintbrush (for selective bleaching)
- rubber gloves

Changing the Palette with Bleach

In this example, the photograph was dipped into the bleach mixture for an all-over bleaching effect, changing the color palette and creating an unexpected composition.

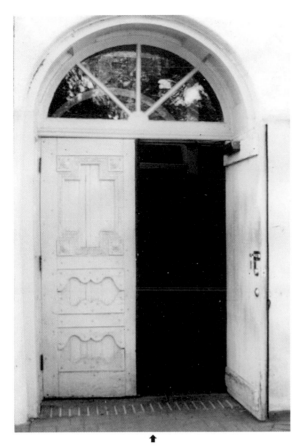

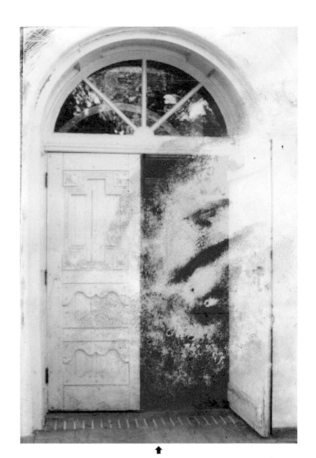

Before bleaching

After bleaching

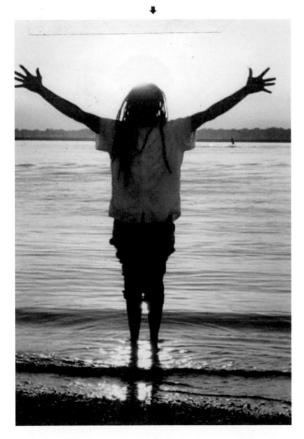

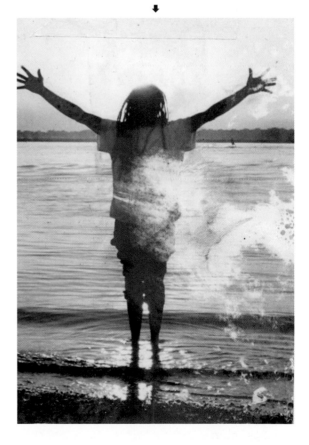

CREATING A BLEACH RESIST

To preserve selected areas of your photograph from the bleaching process, color in your dry photograph with wax crayons before you begin, then follow the process described on page 20. Areas that are not covered with the wax crayon will be altered by the bleach. For a more precise resist, fill in the area you want to preserve with a generous coat of gel medium (enough so that it will not dry quickly and can be rubbed off when you rinse the bleach off in the plain water pan).

Materials

- photograph
- wax crayons
- collage bits
- shallow pan
- solution of 50 percent bleach and 50 percent water
- painted papers
- paintbrush
- rubber gloves

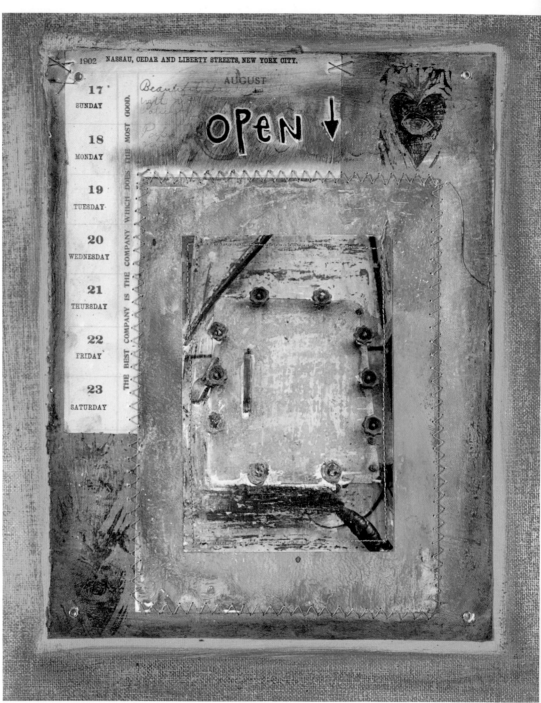

Bleach Resist Photograph

The central photograph in this work of art was prepared with colored wax crayons before the bleaching process. Evidence of the colored crayons can still be seen on the photograph's surface. Once the bleaching process was completed, the photograph was adhered to painted papers and collage bits using gel medium.

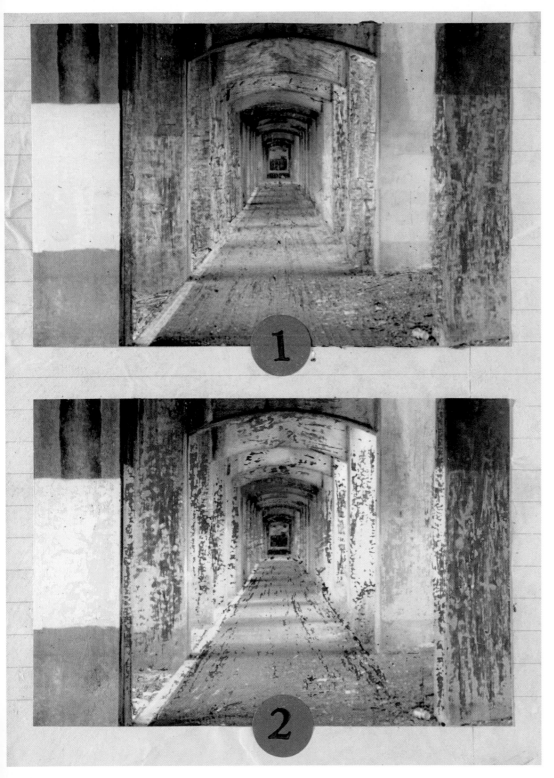

Creating a Bleach Resist with Wax Crayons—Before and After

Materials

- photograph
- wax crayons
- shallow pan
- solution of 50 percent bleach and 50 percent water
- newsprint (optional)
- iron (optional)
- rubber gloves

Photograph 1: The surface is completely colored in with wax crayons. (Be sure that the surface is dry when adding wax crayons to a photograph for resist purposes.)

Photograph 2: You can see the result after the photograph has been dipped in bleach. The reds and pinks that have come through the image. Some of the wax crayon can be rubbed off while the photograph is in the water bath, but most of the crayon markings will remain. If you would like to remove the wax completely, place a sheet of newsprint over the photograph's surface, then place a warm iron on top of the newsprint to heat up the wax. The newsprint will absorb the melted wax.

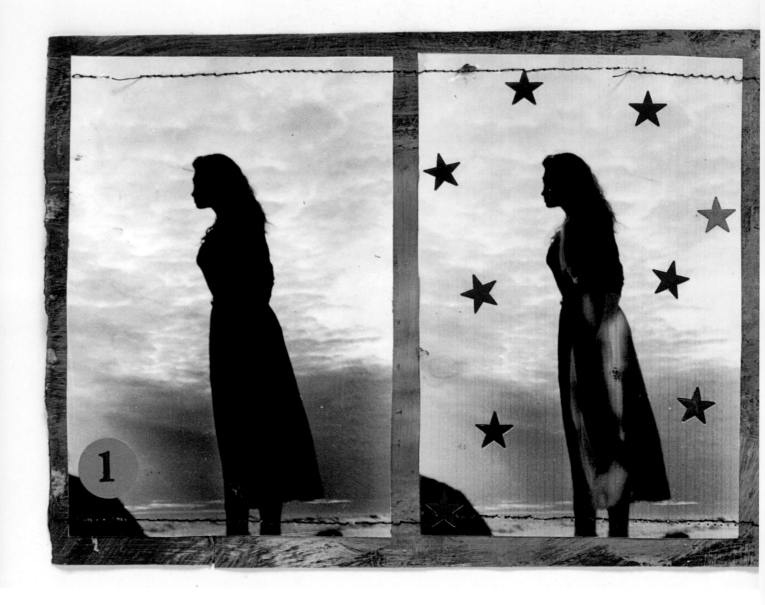

Creating a Bleach Resist with Stickers

Stickers can also serve as tools for creating resists on your photograph's surface. Notice the stars added to the background in **Photograph 2**, along with gel medium protecting the figure of the woman. After processing the image in bleach, as seen in **Photograph 3**, both the star stickers and the gel medium are removed. Because the black–and–white photograph was processed on color-print paper, the yellows and reds come forward during the bleaching process. In **Photograph 4**, the image is finished off with water-soluble oil pastels, which blend well into the background, and gel markers, which are used around the silhouette.

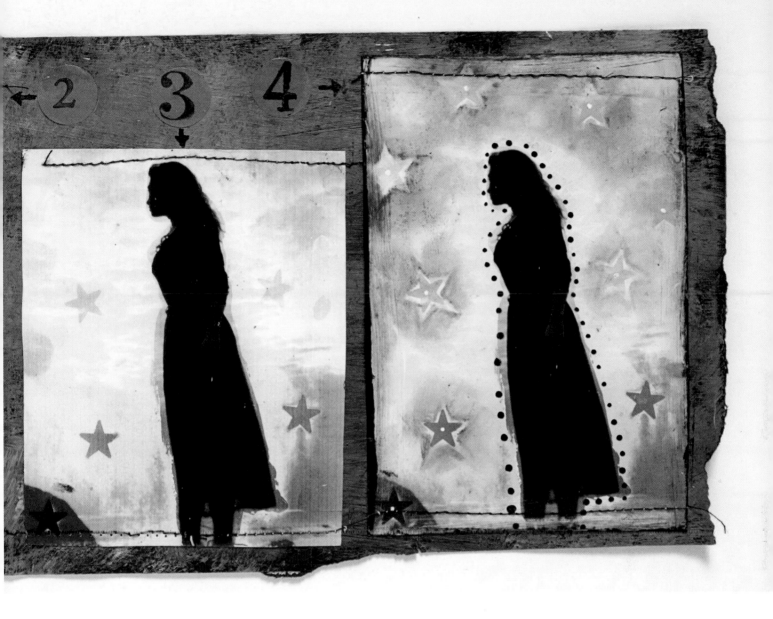

Materials

- photograph
- stickers
- gel medium
- shallow pan
- solution of 50 percent bleach and 50 percent water
- water-soluble oil pastels (optional)
- gel markers (optional)
- rubber gloves

USING BLEACH PENS

Bleach pens can add fine, detailed bleached effects to your photographs. They are also perfect for adding words or creating patterns.

To use a bleach pen, apply it directly onto a dry photograph. Let the bleach sit for about ten seconds, and then wipe it off with a damp paper towel. The longer the bleach sits on the photograph's surface, the lighter the results, starting at red, going to yellow, and then to white. Rinse the photograph in water once the desired results are achieved.

TIP

To achieve more reds in your final image, leave the bleach on for just a few moments. This process works best on darker photos.

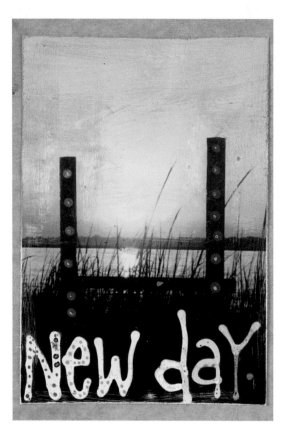

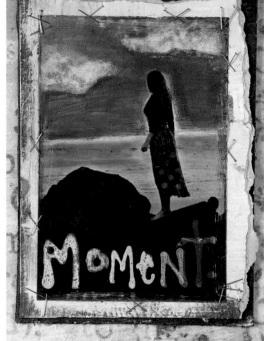

Materials

- photograph
- bleach pen
- damp paper towel
- gel pens (optional)
- watercolor paints (optional)
- shallow pan of water
- fine-grit sandpaper (optional)
- paintbrush (optional)

⬆ Bleach Pens

This photograph was selected for the bleach pen process because the lower portion of the photograph is very dark. The bleach pen was used to write New Day and to add some polka dots to the two poles intersecting the horizon. All the bleach was wiped away at the same time creating varied results. The areas where the bleach sat longer became light yellow to white, whereas the polka dots (the last elements added) became red. For further embellishment, gel pens were used to add color to the white text areas and sanding and watercolors were added to the sky.

⬆ Bleach Pens

Here is an example of a black-and-white negative processed on color-print paper that has been altered using the bleach pen. This photograph uses the same bleach pen process as the photo at the left.

Materials

- photograph
- bleach pen
- damp paper towel
- shallow pan of water

CREATING LIQUID DRANO PHOTOGRAPH TRANSFERS

You can transfer your actual photographs to a new surface. Place enough Liquid Drano in a pan so you can dip your photograph completely into the liquid. When choosing the paper onto which you plan to transfer your photograph, be sure it is at least 65-lb weight and uncoated. These transfers can also be applied to a heavy-weight cotton fabric.

Like the bleaching process, timing is critical. When using this process, be sure to wear rubber gloves and work in a well-ventilated area. To begin, dip the photograph into the Liquid Drano and remove it immediately. Gently drain off the excess liquid, lay the photograph face up on a flat surface, and place the paper on top of the photo. Apply light, even pressure using your fingers or the palm of your hand over the entire photograph and then pull the paper back. Voilà! Let the print dry completely before using it in your art.

Materials

- photograph
- Liquid Drano
- 65-lb uncoated paper
- shallow pan
- rubber gloves

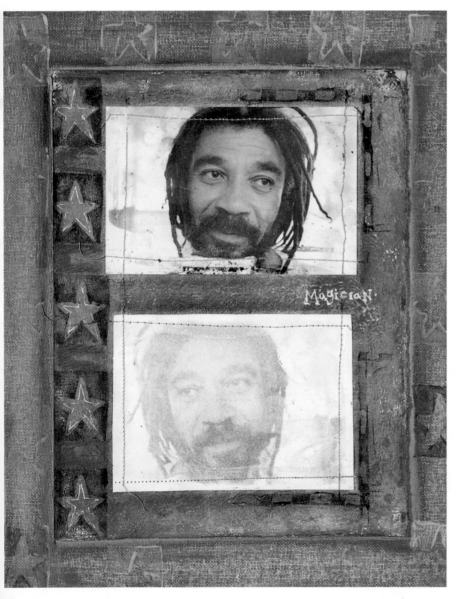

Liquid Drano Transfer— Before and After

On the top portion of this artwork is the original photograph used in the Liquid Drano transfer process without the cyan layer, which has been transferred onto the paper in the bottom portion. The two images have been sewn onto a piece of painted paper and mounted onto a canvas board.

Materials

- photograph
- Liquid Drano
- 65-lb uncoated paper
- painted paper
- hand-held sewing machine
- canvas board
- gel medium
- shallow pan

Combining Techniques and Finishing an Image

You can achieve wonderful results by combining all of the previous processes (with the exception of combining the bleach process with the Liquid Drano process, which is not recommended). After you have altered your photograph and are satisfied with the results, it is a good idea to seal the image with a spray-on varnish that contains UV protection. (Such products can be found in art supply stores.) You can now integrate these new works of art into your art journals, altered books, and collages.

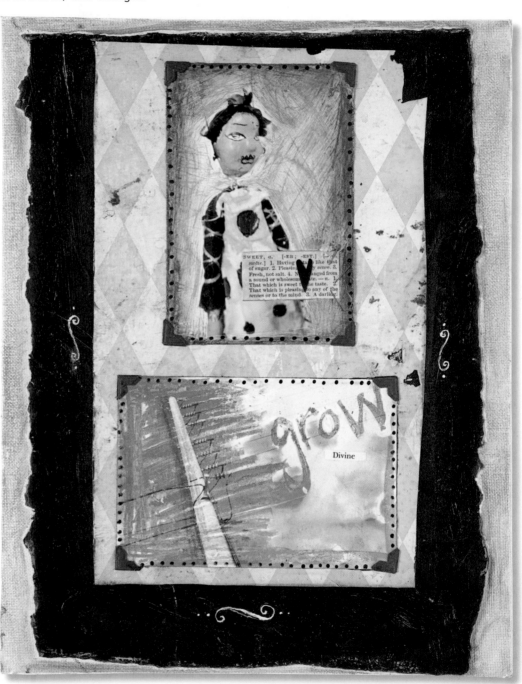

Combined Techniques

These two photographs were created using various combined techniques. The top photograph of the marionette has had the background bleached out and painted, then collaged. The photograph below it was created using the bleach resist process with a little bit of watercolor added afterward.

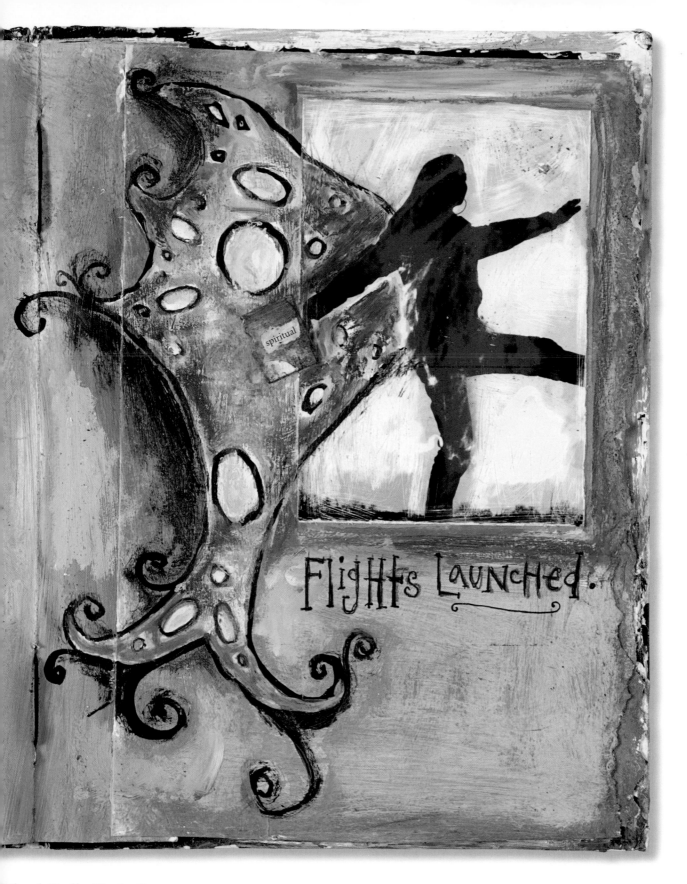

Mixed-Media Photo Page

Using the bleach process, this silhouette photograph was altered and then added to an altered book page using gel medium. Once adhered, the wings were drawn in using graphite, acrylic paints, markers, and oil pastels, integrating the photograph into the page.

ALTERING POLAROID PHOTOGRAPHY

Polaroid cameras have always held appeal for artists because they were the first cameras able to produce an immediate image. This quick image processing enables you to experiment, and work intuitively.

SX-70 FILM EMULSION MANIPULATION

Polaroid Time Zero film for the Polaroid SX-70 Land Cameras offer many altering possibilities. After taking the picture, allow the photograph to develop for approximately five minutes. Using a stylus, or any tool with a rounded tip (that will not tear the surface), apply pressure to the photograph's surface and "move" the emulsion around to achieve painterly results.

You can remove the white tape around the outside of the photograph to expose the photograph's edge for a more organic look.

Once the tape is removed you can also separate the photograph from its backing. By using a damp paper towel, wipe away parts of the photographic emulsion and collage an image behind it. Adhere collaged images with soft gel medium.

Materials
* Polaroid SX-70 Land Camera
* Time Zero Polaroid film
* stylus
* damp paper towel (optional)
* collage materials (optional)

Note: *Be sure to thoroughly wash your hands after contact with the photographic emulsion.*

Example of Altered SX-70 Polaroid Photo ➡

↑ Altered SX-70 Polaroid photograph with white tape border removed

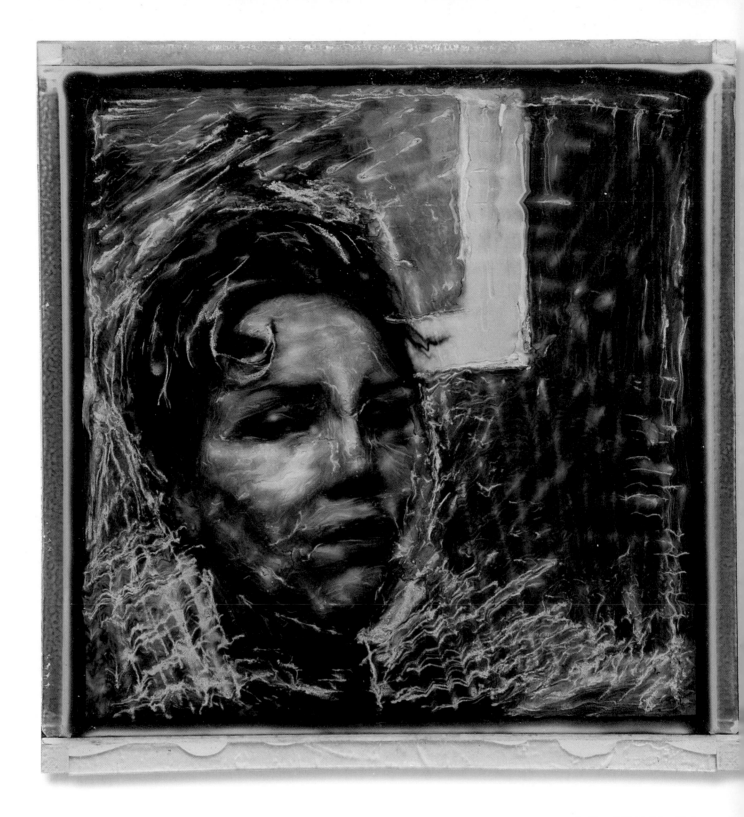

⬆ Altered SX-70 Polaroid photograph with white tape border removed

➡ These altered SX-70 photographs have been adhered to the rest of this collage using gel medium.

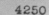

4250

...ETIC...st their glucose
...vel severa...s a day by pricking
...heir finger to obtain a blood sam-
...le—a painful and annoying proce-
...ure. A new technique, however,
...romises to...w...y with needles.
 In a recent study, researchers
...sed low-frequency ultrasound—
...imilar to that used by dentists to
...ly blast away
...uter layer of
...forearm
...the skin

...Once patien...
...o their fore...
...about the...
...asure glu...

...ers
...glucose can
...asured. In
...ients, re-
...echnique...
...pricks.
...en license...
...setts-base...
...g...eloping
 One advan...is develop-
...that it coaxes more...unit and
...through the skin th...
...ods. It also can m...
...stances, such a...

TIME ZONES
1:125 000 000

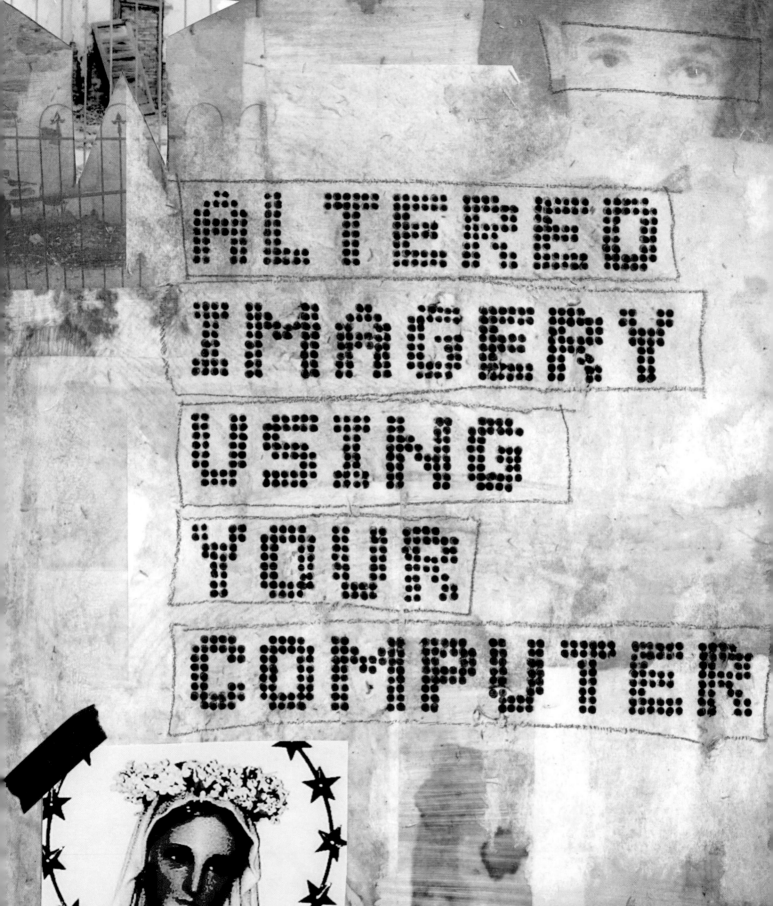

ALTERED IMAGERY USING YOUR COMPUTER

CHAPTER 2:
ALTERED IMAGERY USING YOUR COMPUTER

The beauty of home computers and the widespread use of digital cameras is the opportunity to have your own photograph manipulation and printing lab at your fingertips! Most computers (and cameras) now come with basic image-editing software. The programs are fairly easy to use, and most of the basic functions are standard from program to program. Images can be enlarged, adjusted for color, and cropped. You can also apply various special effects that blur or sharpen the image, or even change it to duotone or black and white. You can also scan in nondigital photographs and then alter them with your software. After printing your results, your photograph is ready for further alteration with traditional materials, if you desire.

WORKING WITH SCANNERS

You may not want to alter those old, one-of-a-kind photographs passed down from family members, but you may want to integrate them into your artwork. The best way to work with, as well as preserve, these photographs is by scanning them. When scanning your photographs for print, scan them at 150 to 300 dpi (dots per inch). This setting determines the photograph's resolution; the higher the resolution, the better the quality of your printed image. For images that you plan to use for on-screen viewing, either on your computer screen or on the Web, scan them at 72 dpi.

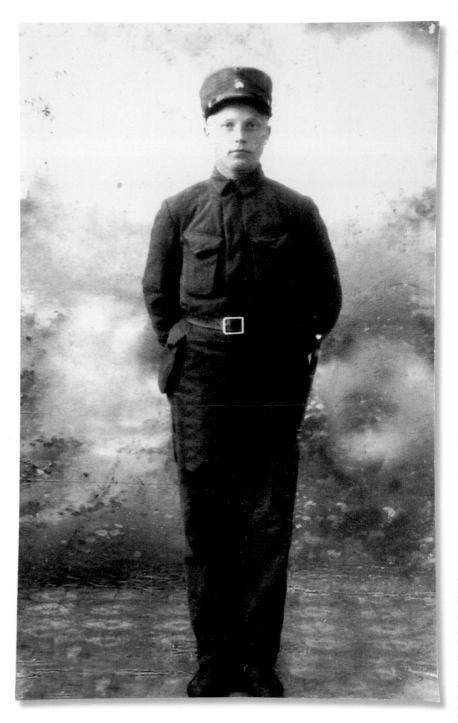

Scanning photographs into your computer will give you the opportunity to correct any brightness and contrast issues and to edit out any scratches on the surface of the photo. Once the photograph is scanned, save a copy of the raw file before making any digital changes. This way, you will always have a copy of the original. Save images in the native file format of your editing software or as a TIFF, PNG, or BMP (bitmap) to preserve the quality of your image. Now you are ready to alter your scans.

TIPS

Clean the scanner glass with glass cleaner and a paper towel before scanning.

Avoid saving your images as JPEGs, as this format loses quality each time you edit and save the image.

Once you have archived your photographs by scanning them, consider burning them onto CDs as back up and to free up hard drive space since image file sizes can be quite large.

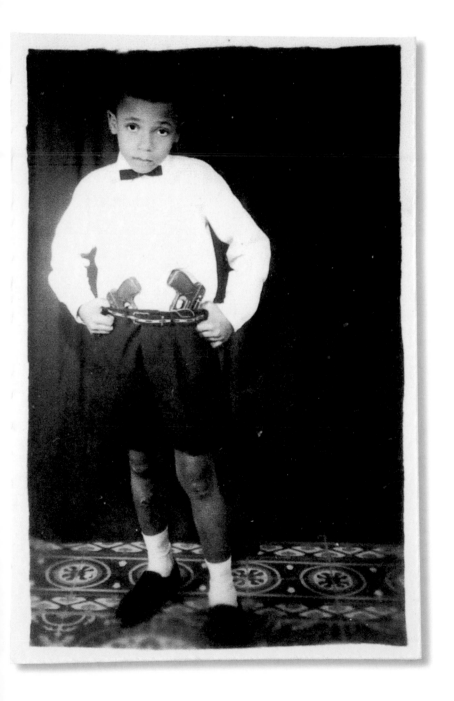

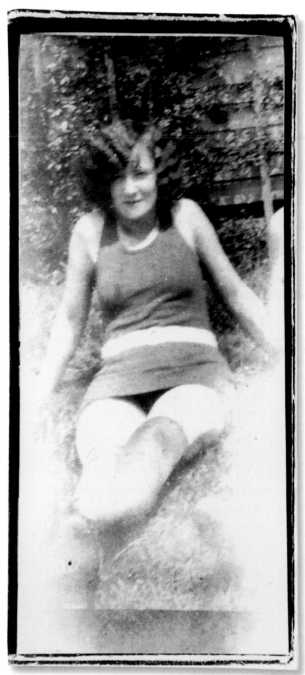

ALTERING IMAGES USING IMAGE-EDITING PROGRAMS

Most new scanners and computers come with image-editing software. Read the help files and tutorials that come with the program to give you a better understanding of how your scanner works with the program and to guide your through the editing and altering features that the program offers.

Images taken on digital cameras can also be imported into these editing programs and then manipulated. If you do not have a digital camera, many photograph-developing services will place your film images onto a CD for you when they process your film.

After you copy the photograph onto your computer from the CD or digital camera you can play with the image and alter it digitally—without even getting your hands dirty!

GENERAL TIPS FOR DIGITAL IMAGE ALTERING:

Brightness and Contrast

For images that are too dark or too light, try adjusting the brightness and contrast. For a more dramatic result, bring the contrast up high.

⬆ In order to bring out the details more dramatically in this photograph, the contrast was increased to bring the lightest colors up to white and the darkest colors down to black.

Color Variations

Color variations change the overall color of the image, converting the image to the selected color. This feature is good for creating a color-wash effect.

⬆ To create the somber, dreamlike feeling in this photograph, the color was adjusted by adding tones of blue.

Cropping and Enlarging

You may want to use only a portion of your image. Cropping your image to a selected area can remove unwanted elements in your composition. When enlarging your image, however, remember that making it too big can result in loss of image quality.

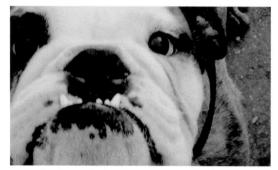

⬆ For this photograph, the image was enlarged and then cropped around the dog's face, resulting in a fun loving, offbeat portrait.

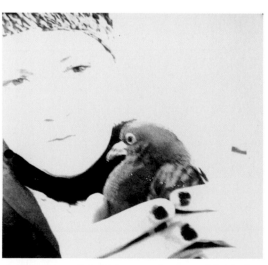

⬆ In this photograph the brightness was first increased slightly, then the contrast was brought up high to wash out the lighter colors and emphasize the darker elements.

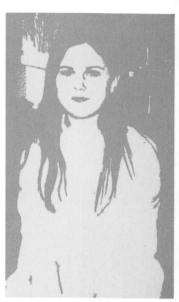

⬆ Before adjusting the color variations in this photograph, the brightness and contrast were brought up high. Next the image was converted from RGB color to grayscale in order to remove all color and create a clean palette. The image was then converted back to RGB so that it could accept new color applications in tones of magenta.

Color Hue and Saturation

Color hue and saturation can be used to either correct the color of an image or create some interesting results. Changing the hue alters the color palette globally, adjusting all of the colors within the image. Changing the saturation adjusts how much of the hue is used. The higher the saturation, the more exaggerated the result.

← This group of images depicts the same photograph with different color hues applied to each. The color was given even saturation over the entire photograph. Notice how changing the hue affects all of the colors within the photo.

↓ In this image, the color hues were not changed, but their saturation was increased to create an exaggerated, "posterized" effect.

Reversing and Mirroring

Images can be reversed or mirrored, depending on what you plan to do with them once they are printed. This process is helpful when doing ink-jet transfers, since you need to mirror text before transferring it so that it reads in the right direction. (See more on this process on page 41.)

← Twins? Actually, this image began with one bird which was copied, reversed and mirrored and then pasted onto a digitally created canvas.

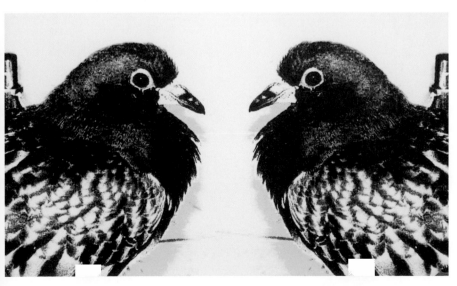

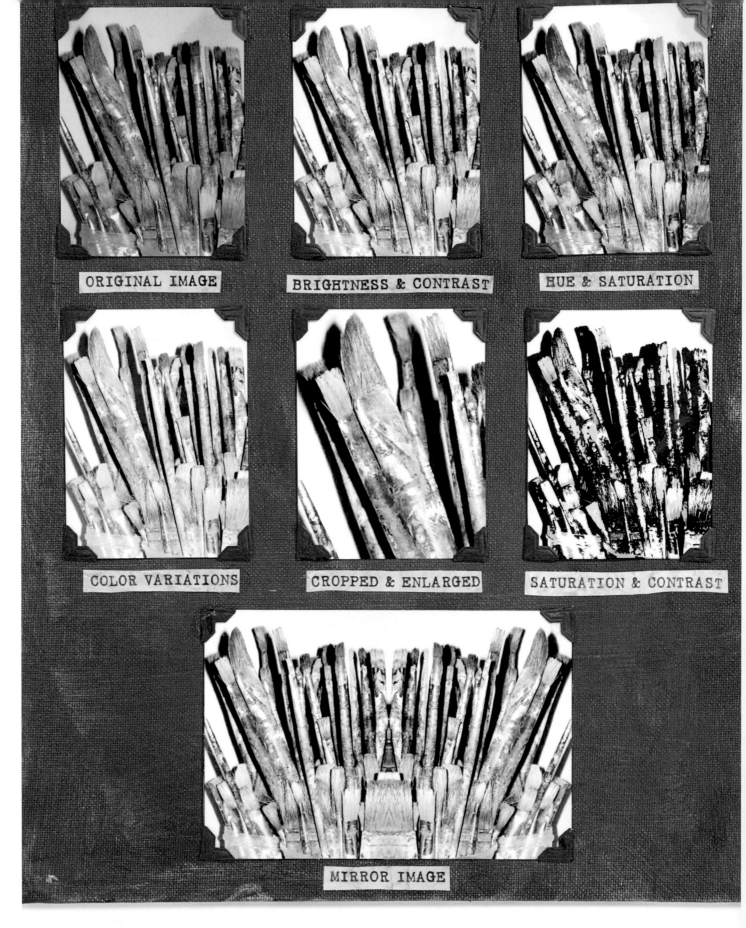

ORIGINAL IMAGE

BRIGHTNESS & CONTRAST

HUE & SATURATION

COLOR VARIATIONS

CROPPED & ENLARGED

SATURATION & CONTRAST

MIRROR IMAGE

Digital Image Altering

Here you can see how the same digital image has had various techniques applied to it.

WORKING WITH PRINTERS

Having a printer in your home or studio allows you to make multiple prints of your images for fun and experimentation. Whether you are using an ink-jet or laser printer, there are many fun ways of integrating your imagery into your artwork.

INK-JET PRINTERS

Many new computers come with ink-jet printers. Printing onto photograph-quality paper can produce a beautiful image for adding to your artwork. Because the inks used in ink-jet printers are water-based, you can transfer your image onto other surfaces as well.

Materials

- digital photograph printed on photograph-quality ink-jet paper
- soft gel medium
- heavy-weight paper
- gesso
- paintbrush
- brayer

Creating Ink-jet Transfers

Print your image onto photograph-quality paper. If you want to transfer your image onto paper, it is a good idea to use a heavy-weight paper (such as Arches), or prime the paper with gesso first. Apply a thin, even coat of soft gel medium to the area onto which you want to transfer the image, and place the ink-jet image facedown onto the gel. Using a brayer, apply even pressure to the back of the image, and let it sit for approximately two to three minutes. Test the transfer by pulling back a corner and checking to see if the image has transferred onto the gel. If the image has transferred, continue to peel off the paper.

TIPS

Ink-jet transfers create a negative transfer, so if there is text in your image, be sure to mirror your image before printing.

Experiment with different types of paper. Try the same process with standard-weight colored papers to add colored paper fibers to your transfer. Or, print your images onto ink-jet transparency paper for crisper, cleaner results.

⬇ The central image is an example of an ink-jet transfer created from an image printed onto photograph-quality paper. Note that the edges are not necessarily perfect. This is the nature of ink-jet transfers.

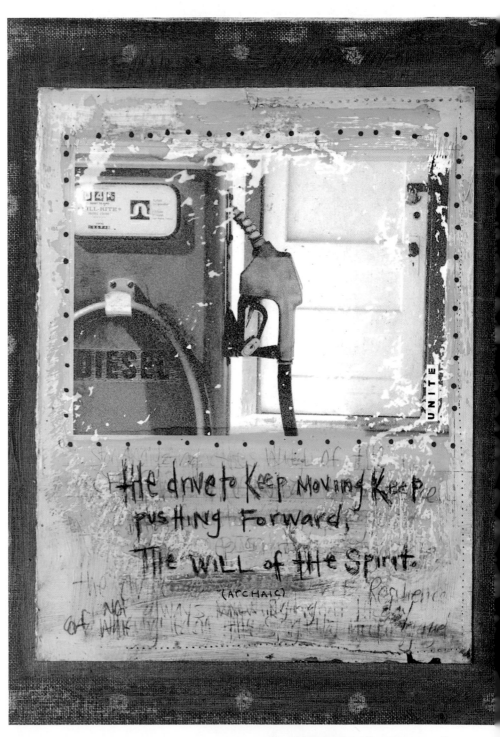

LASER PRINTERS AND COPY MACHINES

Laser printers use toner cartridges. You can transfer toner inks using clear packing tape or clear contact paper. Print the image onto regular-weight computer paper, and trim away the excess paper. Place the tape or contact paper directly onto your image, and apply pressure to the surface to remove any air bubbles. When all the air bubbles have been removed, place the image in a pan of water and let it soak until the paper is completely saturated. Using your fingers, rub away the paper until all the paper pulp is removed and you have just a clear transparency of the image (on the tape or contact paper). To attach the transparency to your artwork, apply gel medium to the surface to which you plan to add your transfer, then lay the transparency over the top.

TIPS

Toner transfers make a positive transfer, so there is no need to reverse any text in your image.

Warm water tends to activate the process more quickly than cold water.

Heavier-weight papers will work as well but must soak a little longer than light-weight paper.

Materials

- image printed from a home laser printer or commercial toner copier
- clear packing tape or clear contact paper
- shallow pan of water
- gel medium

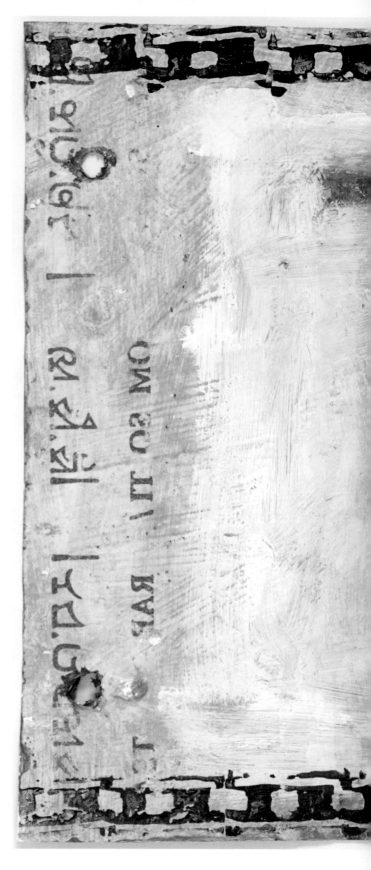

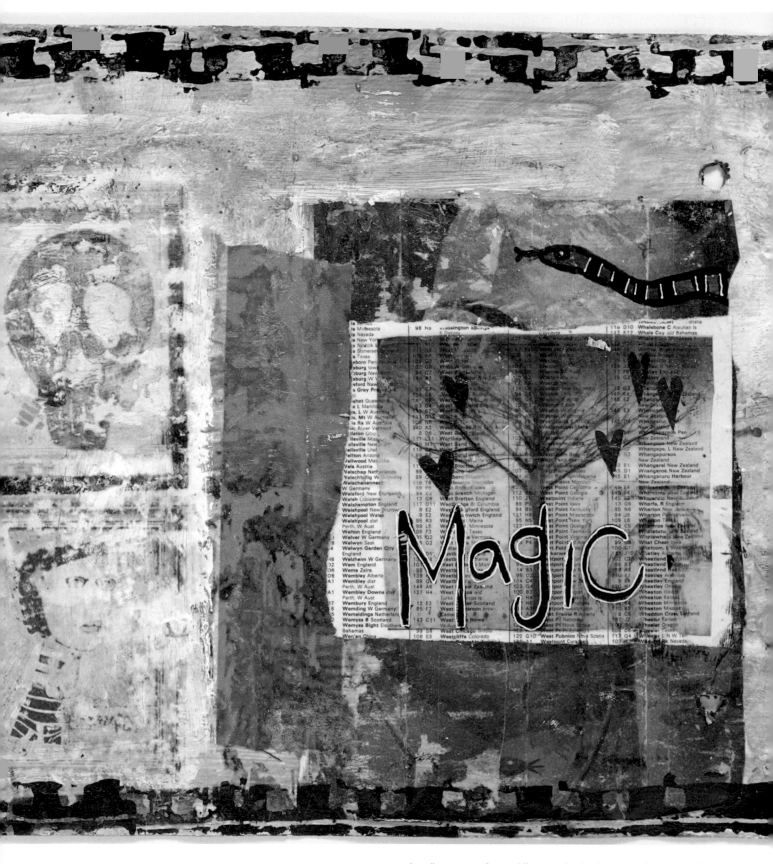

↑ This collage consists of many different combined techniques. On the right side, the image of the tree silhouette is a tape transfer from a toner copy image. After the paper was soaked off the back, the tape was adhered to a printed sheet of paper using gel medium. The tree branches were then embellished using red foil hearts adhered with gel medium. The word *Magic* was written using gel markers.

...sit through Scorpio, ... g you
use. A loved one encourages yc
...vel... ...plifti...itual
...ur
...d e
...e 1
...and
...be
...tur
...1
...mi
...po
awareness
...on
...let
in y
aw
...onfid
-set developing. Your self estec

stirs your soul

CHAPTER 3:
ALTERED IMAGERY FROM FOUND SOURCES

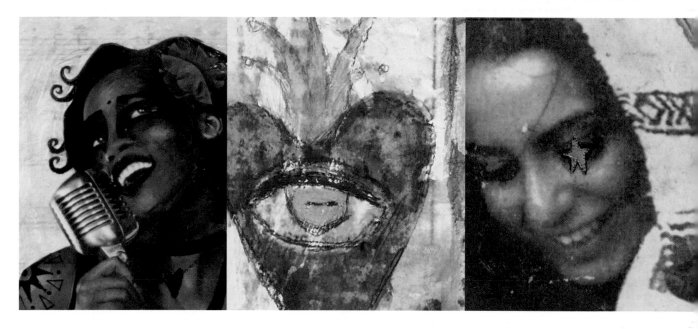

Keeping your eyes open for collage materials while browsing through magazines, catalogs, junk mail, or even billboards to provide a wealth of imagery to work with as you experiment and try new techniques. Creating collages using various types of found imagery from different sources can create unusual and compelling compositions. Keep in mind that each added element carries with it its own implications, and when added to other collected ephemera, together tell an interesting story.

EXPERIMENTING WITH MAGAZINE COLLAGE

Magazines offer abundant imagery that can inspire you to create. One thing to keep in mind, however, is that magazine images were taken by a photographer or were photographed for a company who own the rights to the image. Although altering the image and making it your own by means of paint and further collage transforms the original piece into something new and different, you may want to familiarize yourself with copyright laws by visiting www.copyright.gov and www.funnystrange.com, particularly if you plan to sell your artwork.

COLLAGED PORTRAIT: BUILDING CHARACTERS

Fashion magazines offer lots of close-ups that can be used in interesting ways to create unusual and expressive portraits. Try collecting various eyes, noses, lips, and skin tones to build portraits and create new characters. Canvas board makes a good, solid base for a collage. Apply a thin, even coat of gel medium to the surface of the canvas board. Begin your portrait by laying your paper pieces over the top. Consider cutting hair images from magazines into shapes and style to add to your portrait. Accessorize as desired. Once you have placed all your papers in position onto the gel medium, consider adding an additional layer of medium to seal together all the papers and adhere any little paper "stragglers" that may be sticking up.

In this collage, the different facial features in various skin tones were collected from numerous models. Different hair textures and colors were collected and cut to shape to compose her hair style. The background, as well as her shirt, were created from a selection of patterned cutouts shaped to fill in the negative space (the space around the model). Further embellishment was done with a gel marker by outlining the face and hat, pulling all the bits of paper together to give proper form to this portrait. Working with the iconic imagery of the cowboy hat, the word *Americana* was written along the sides with a black gel marker, creating a frame for the image as well as telling a story about this unusual character.

Materials

- canvas board
- facial and hair features cut from various magazines
- gel medium
- gel markers

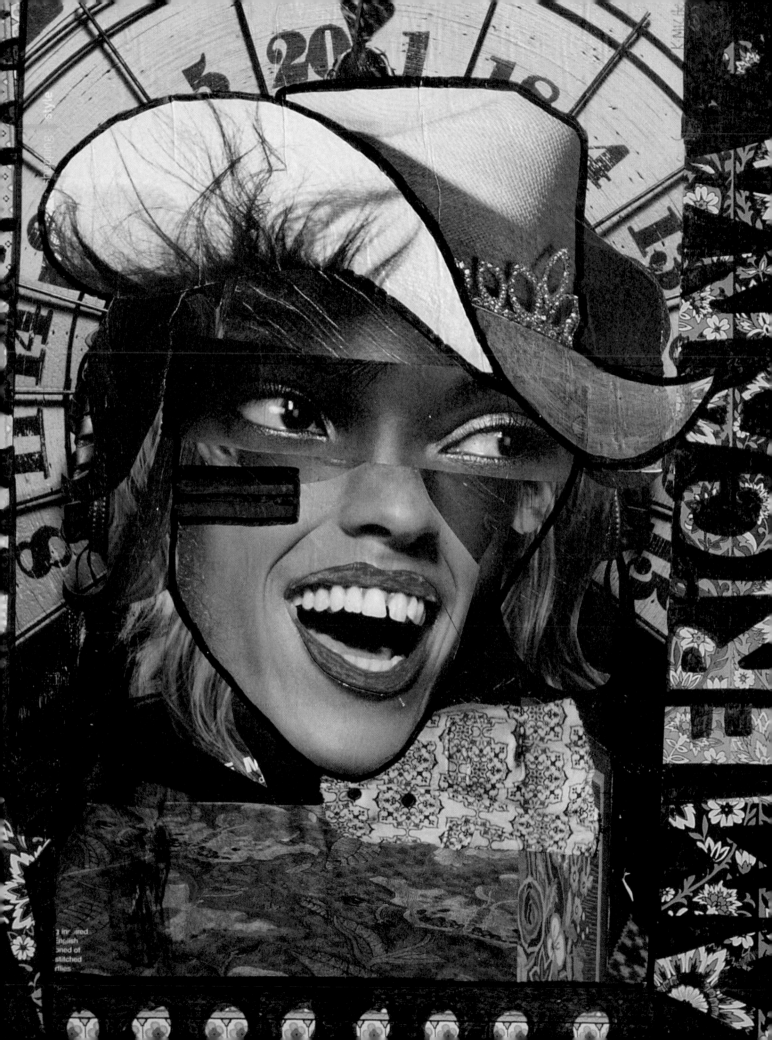

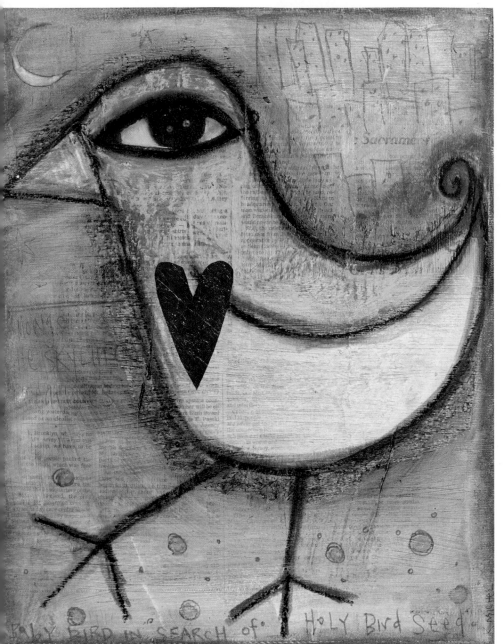

Creating a Collage Background

For an interesting background for a collage, consider the morning newspaper. Apply gel medium to your collage surface and place bits and pieces of the newspaper onto the gel until the entire surface of the canvas board is covered. When you have completely covered the surface, seal the newspaper with an additional layer of gel medium. After the gel medium is dry, apply a layer of gesso thin enough so you can vaguely see the text through the gesso. After the gesso dries, you have a "toothy" surface that is ready for additional collage elements, drawing, or painting.

In the collage at left, the bird was drawn with water-soluble oil pastels on top of the gessoed newspaper. Water-soluble oil pastels can be blended using your fingertip or a damp paintbrush. In this example, the colors were blended using a damp paintbrush and then reapplied to deepen and texturize the colors in certain areas. To give this bird the "knowing gaze" that so many urban birds seem to possess, an image of a human eye was cut from a magazine and glued onto the surface using gel medium. Further drawings of the skyline and writing were added using a graphite pencil. Graphite pencils in sizes 8B to 10B allow you to make dark, almost creamy, marks onto the surface, which you can easily blend with your fingertips.

Water-soluble oil pastels never fully dry to the touch, so once your work is finished, consider sealing it with a spray fixative—preferably one with UV protection so the vibrant colors do not fade over time.

Materials

- newspaper
- gesso
- water-soluble oil pastels
- gel medium
- cutout of human eye
- spray fixative with UV protection
- 8B–10B graphite pencil
- paintbrush

Adding Collaged Background Elements

In the collage below, the background was embellished after the imagery was drawn and painted. The bird and landscape were drawn using gel markers, and the sky and earth were painted in with acrylic paints. To give the sky and earth a deeper dimension, bits of astrological text and sheet music were gelled on top of the paint and then painted over to integrate them into the background. The human eye cutout was also added using gel medium and further enhanced with a white gel pen. The wooden frame was a great find from a thrift store. To bring new life to the frame, it was sanded and repainted to showcase the collage, adding more space around the main focal image of the bird, finishing the piece nicely.

Materials

- gel markers
- acrylic paint
- gel medium
- gel pens
- collected text from printed sources
- wooden frame
- paintbrush
- sandpaper

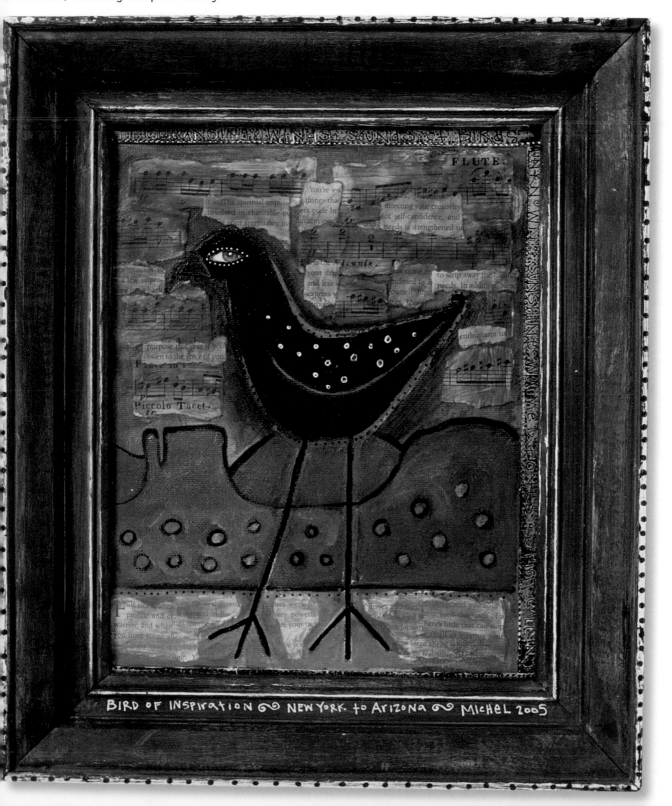

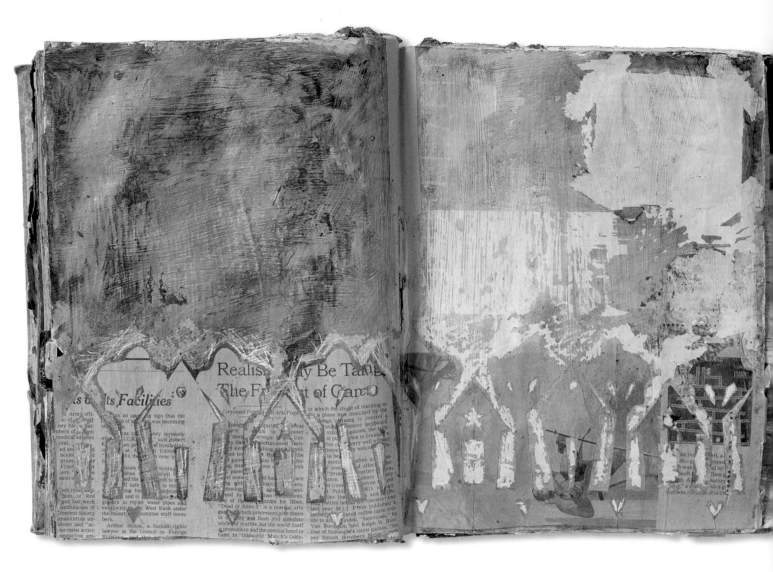

Paper Chains

Remember the paper doll chains you made as a kid? This altered book spread consists of a cut-out chain of homes and trees. Begin with a long piece of paper (a newspaper was used in this instance) folded vertically several times and sized to fit your composition. Sketch your design onto the paper, and cut away the unnecessary areas around your sketch, remembering not to cut away the folds completely on the sides because this is what will keep your chain together. In this spread, the background was primed with gesso and then worked with water-soluble oil pastels. The paper chain was then adhered to the surface with gel medium. The colored areas around the paper cutouts were scratched away using an awl to better integrate the paper cutouts into the overall composition.

Materials

- newspaper
- gesso
- gel medium
- water-soluble oil pastels
- awl
- paintbrush
- scissors

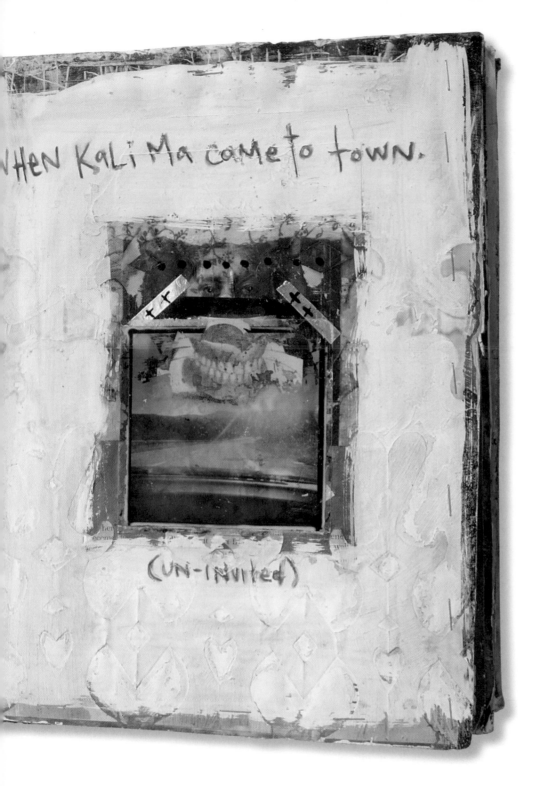

Materials

* newspaper
* gesso
* gel medium
* liquid watercolors
* printed imagery
* Polaroid photo
* warm water
* paintbrush
* scissors

Using Paper Chains as Background Elements

The background for this altered book page was created using the same paper chain technique described on page 50. The paper chain was painted with liquid watercolors and, when dry, repainted with gesso. In certain areas, the gesso has pulled the watercolor up to the surface creating interesting color variations. The inner collage was created using various pieces of printed imagery and finished off with a Polaroid photo on top. Rinsing off some of the photographic emulsion from the Polaroid with warm water allowed the imagery beneath to peak through, creating a surreal landscape of images.

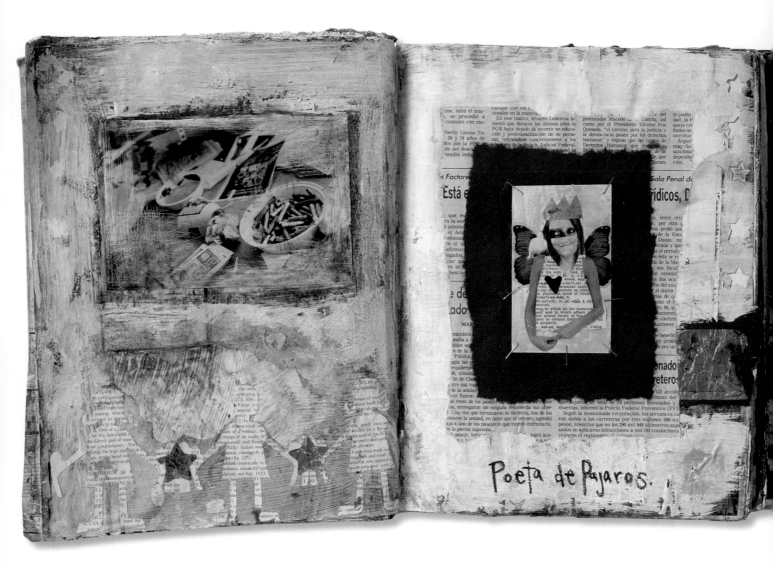

Using Staples to Adhere Papers

This collaged page from an altered book revisits the portrait-building process of collecting different facial features from printed sources and assembling your own character. In this collage, our little poet is gelled onto a paper background, which is stapled onto a colored sheet of handmade paper, then glued onto a sheet of newspaper, which is then added to the book. Staples offer a textural and decorative option for adhering papers; they are even available in several wonderful colors.

Materials

- printed imagery
- gel medium
- stapler and staples

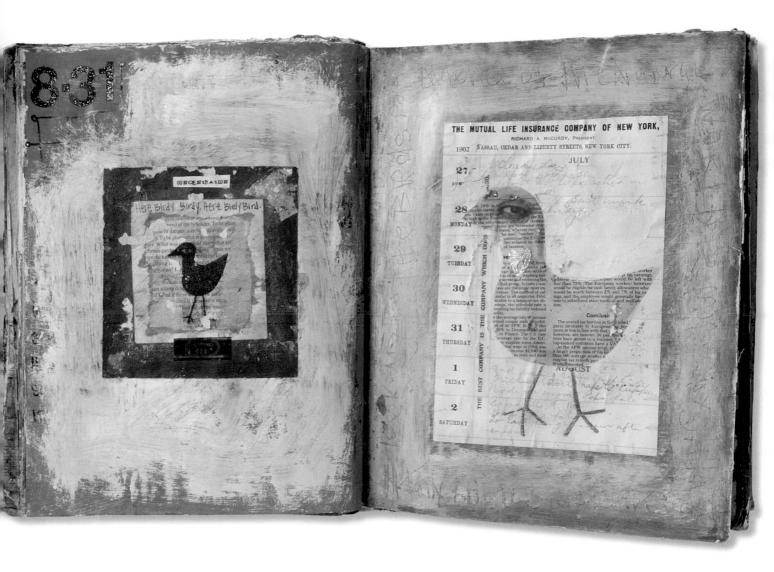

Materials

- printed imagery
- graphite pencil
- gesso
- blue acrylic paint
- gel medium
- awl
- paintbrush
- scissors

Creating Basic Forms Using Printed Imagery

This simple collage is a great example of using printed imagery for the basic forms of your collage. Here the bird's body was cut from a printed page of text and glued onto a vintage diary page. The eye was found in a magazine, and the shading around the eye and feet was sketched in with a graphite pencil. The background was created by priming the page with gesso. When the gesso dried, a layer of blue acrylic paint was added, and the collage was glued onto the surface with gel medium. To better frame the collage within the page, the areas surrounding the collage were reworked with gesso and writing scratched into the surface with an awl.

LAYERING TRADITIONAL ART MEDIA OVER A COLLAGE

Gel pens and markers are great tools for altering the surface of a magazine image. Every style of marker or pen offers unique results. Glazing gel pens are wonderful for blending transparent tones of color on faces and background, whereas gel markers are good for filling in large areas of opaque color.

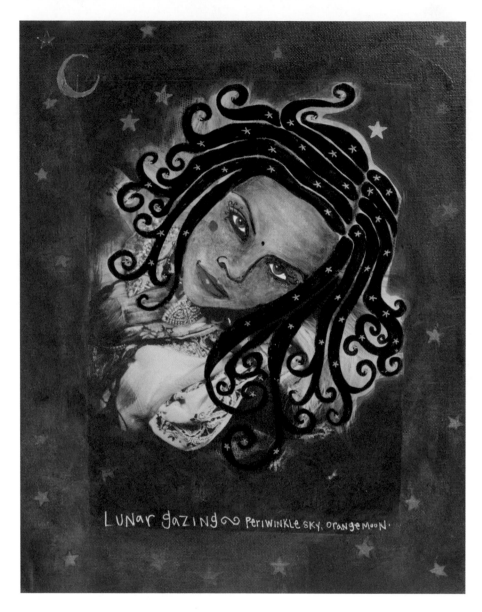

Materials

- printed imagery
- canvas board
- gel medium
- gel glaze pens
- gel markers
- acrylic paints
- paintbrush

Mixed-Media Magazine Portraits

This piece began with a beautiful photograph torn from a fashion magazine. The initial inspiration was the interesting perspective of the woman's face, how she was gazing at the camera with her hair streaming around her. The entire page is glued onto a canvas board with gel medium, and her main features are retraced with a black gel glaze pen, changing the shape of her eyebrows and nose line. The highlights on her face were filled in using a yellow glaze gel pen, graduating to the shadows with orange and the darkest shadowed areas with violet. Her blonde locks were turned into black-star-embellished Medusa-like curls with a black gel marker and a metallic silver gel pen.

To unify the page to the canvas board, a coat of purple acrylic paint was used to fill in the negative space around the portrait, and an additional layer of blue acrylic was painted on top, adding stars and a moon.

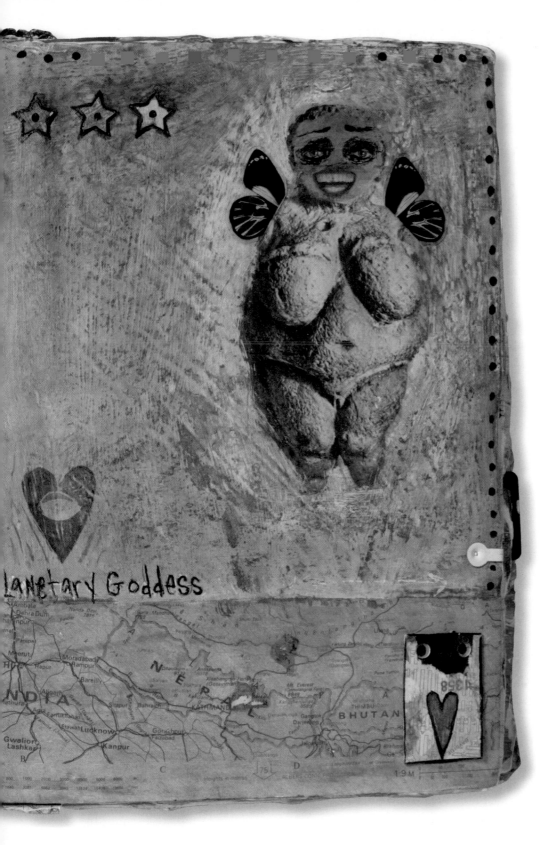

Materials
- printed imagery
- gesso
- gel medium
- water-soluble oil pastels
- hand-carved stamps
- paintbrush

Adding New Life to Old Characters

This collage comes from an altered art history book. With the rest of the background gessoed out, the sculpture The Venus of Willendorf becomes the main element. The background is then reworked with water-soluble oil pastels, hand-carved stamps, and collaged maps. Venus herself is then altered by adding collaged facial features and a delicate set of wings with gel medium.

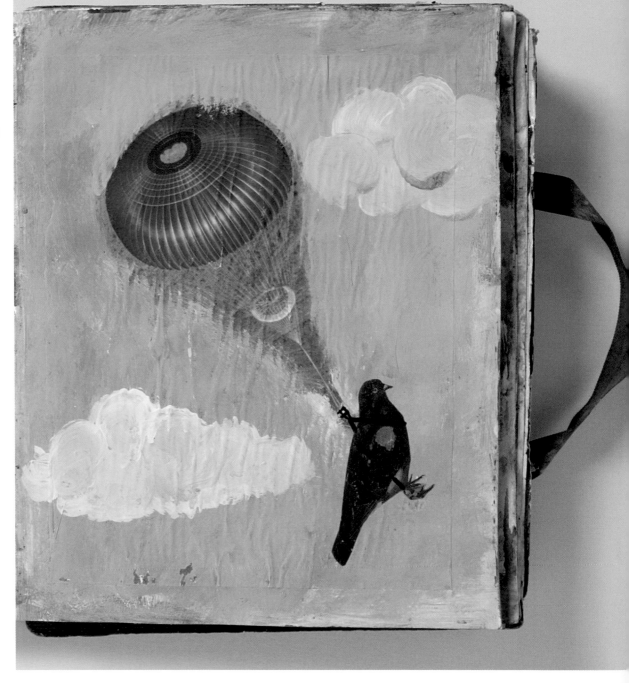

Materials

+ printed imagery
+ gel medium
+ gesso
+ acrylic paints
+ paintbrush

Using a Background to Unify Your Collage

When combining different paper elements, a background may help unify your imagery, as shown in this collage. The parachute was glued onto the page first, and then the unnecessary elements of the background removed with gesso. The sky and clouds were then painted in with acrylic paints, and the little pigeon was glued onto the painted surface. (So why would this little bird need a parachute? An extra security precaution, perhaps. Telling a story with imagery offers the opportunity for interpretation not only to the creator but also to the viewer.)

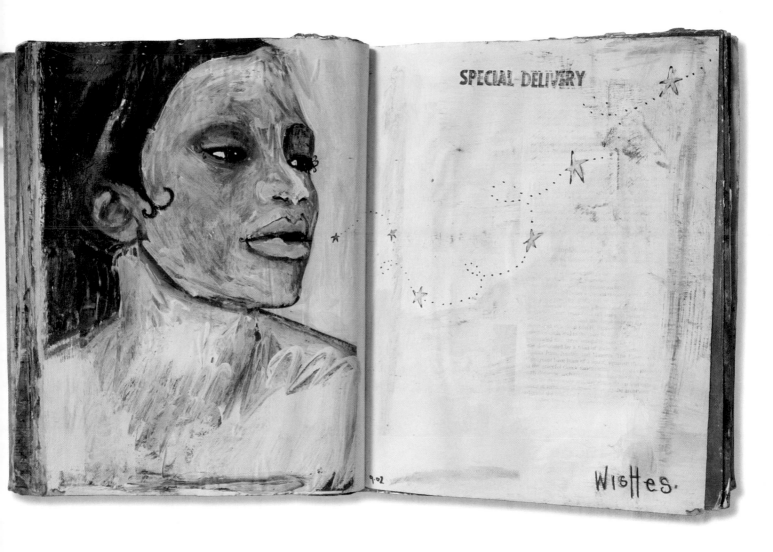

Materials

- magazine photo
- acrylic gel
- gesso
- water-soluble oil pastels
- gel pens
- paintbrush

Gesso Portraits

This art journal spread began with a photograph from a magazine that was gelled onto the page. The facing page, as well as her face and body, were painted over with gesso. Working the gesso lightly over the image allows you to work with the existing highlights and shadows within the photo. Subtle color enhancements were made with water-soluble oil pastels to accentuate the shadows of her face. This is a great practice for understanding lights and shadows within portraits. The doodles and finer facial markings were created using gel pens.

INTEGRATING FOUND OBJECTS

As you move along in your day-to-day adventures, you may come across found objects that "speak to you" or that seem to tell a story. These objects can be great companions for your altered imagery. The following projects show you how to integrate such objects into your artwork.

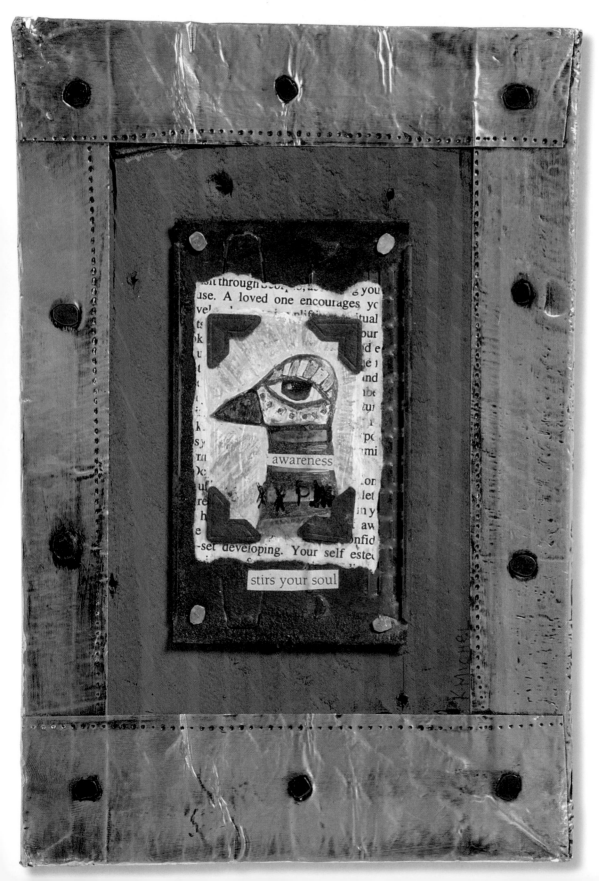

Materials

- found objects
- printed imagery
- gel pens
- photograph corners
- gel medium
- aluminum ventilation tape
- india ink
- carpet tacks
- stylus
- pattern wheel
- hammer
- rag
- brayer

Working with Found Objects

This piece consists of two found objects—the big hunk of wood and the rusted rectangular piece of metal in the center. These objects were found on separate occasions, but in both cases, their naturally aged surfaces were their most enticing feature. The collaged portrait of the bird was created with gel pens and mounted onto horoscope text. The corners of the portrait were enhanced using black photo corners, giving it the look of a photograph right out of an old family album. The collage was mounted onto the found metal rectangle by applying a coat of gel medium to the back side of the paper.

The thick block of wood made for a substantial base, but it needed a defined edge. Using aluminum ventilation tape, a metal frame was added around the edges. Aluminum ventilation tape is commonly used for heating and air-conditioning ductwork and can be found in most hardware stores. Muffler tape (found in auto supply stores) is a similar product with a slightly thicker gauge and can be used in the same fashion. The tape comes with a heavy-duty adhesive, so all you need to do is cut your length of tape, carefully pull off the wax paper from the back side, and place it onto a clean, dry surface. Designating a specific pair of scissors for cutting this tape is suggested because the adhesive will render your scissors useless for cutting anything else. After covering the surface, use a brayer to roll out all the extra air bubbles under the tape to be sure that the tape is well adhered to the surface.

This metal is soft enough to make impressions using a stylus or even a ballpoint pen. Draw designs or write directly onto the surface with any tool that has a point but will not tear, or hammer metal stamps onto the surface. In this piece small dots around the inner frame of the tape. These marks, which are meant to give the area a faux riveted look, were easily achieved using a metal pattern wheel. (This tool is fast compared to drawing each dot independently!)

To synthetically age the aluminum, use a clean rag to wipe off the surface of the tape, and then cover the tape completely with black india ink, allowing the ink to sit on the surface for about two minutes. (Timing will change, depending on humidity—lower humidity will speed up the drying process; higher humidity will slow down the process.) This is a three-step process: First, blot the excess ink from the surface with your rag. Do not rub at this point. Allow the remaining ink to settle into the edges and marks you made for an additional two minutes. Second, rub off the remaining wet ink with a clean rag. When all the wet ink is removed, you can buff the surface with your fingertips, bringing the surface to a shine but keeping the ink inside the crevasses. You can repeat this process as many times as needed to achieve a surface you are satisfied with.

To bring these two objects together, nails were used instead of adhesive. The advantage of working with wood is that you can hammer and drill your objects onto the surface. In this piece, carpet tacks were used to attach the metal collage to the wood. A hardware store offers tacks in various sizes and finishes. To add the finishing touch, darker carpet tacks were hammered in to embellish the wood along the edges and sides, creating a nice range of metal tones throughout the piece.

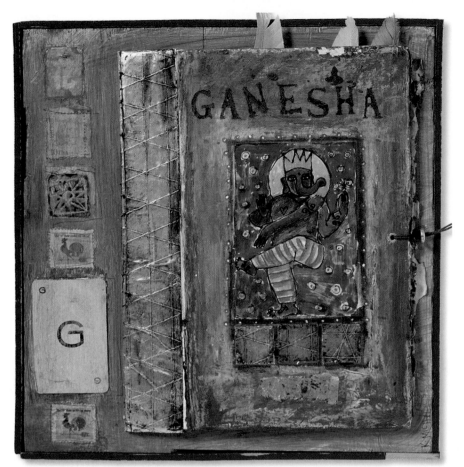

Bringing Together Found Objects

Various found objects are brought together in this piece: vintage stamps, playing cards, an old pair of scissors, bird feathers, and even an antique book cover. The book cover was rebound using aluminum tape (for more about using this tape, see page 59) and was then hammered onto a wooden base with carpet tacks. Because this piece is meant to be mounted on a wall, the scissors are tied to a string that is strung from the front cover and through a looped screw on the wooden base, allowing them to hang freely while keeping the book closed. The string is just long enough to allow the book to be fully opened. All the elements were altered using acrylic paints and water-soluble oil pastels and adhered to the surface using gel medium.

Materials

- found objects
- paper imagery (e.g., vintage stamps, playing cards)
- antique book cover
- aluminum tape
- wooden base
- carpet tacks
- string
- looped screw
- acrylic paints
- water-soluble oil pastels
- gel medium
- hammer

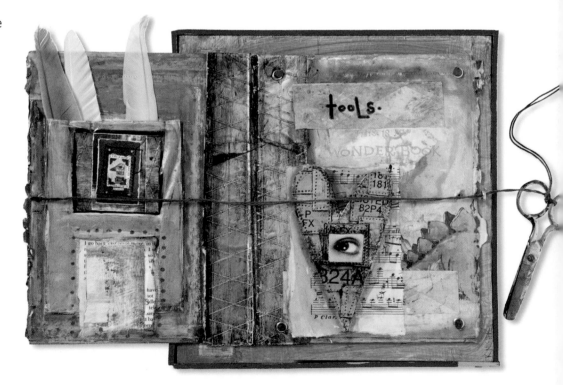

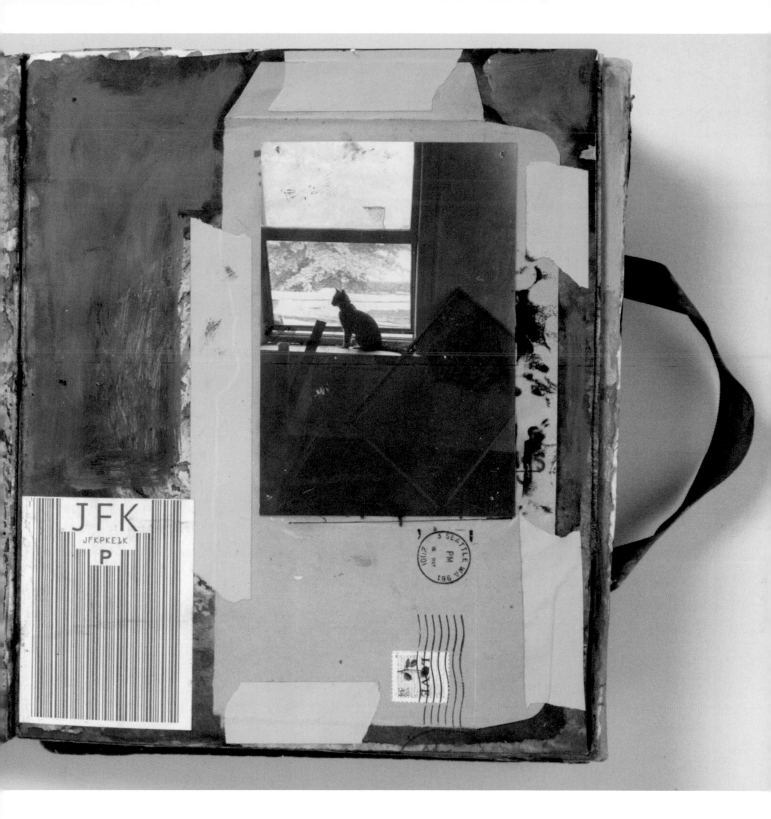

Materials

- found imagery
- gel medium

Combining Paper Sources and Objects

This collage consists of imagery from found sources, such as an old envelope and a bar code from a luggage tag, which are used as backdrops for this photograph. All elements were adhered to the surface using gel medium. Using found paper sources can help build a visual story where words are not necessary.

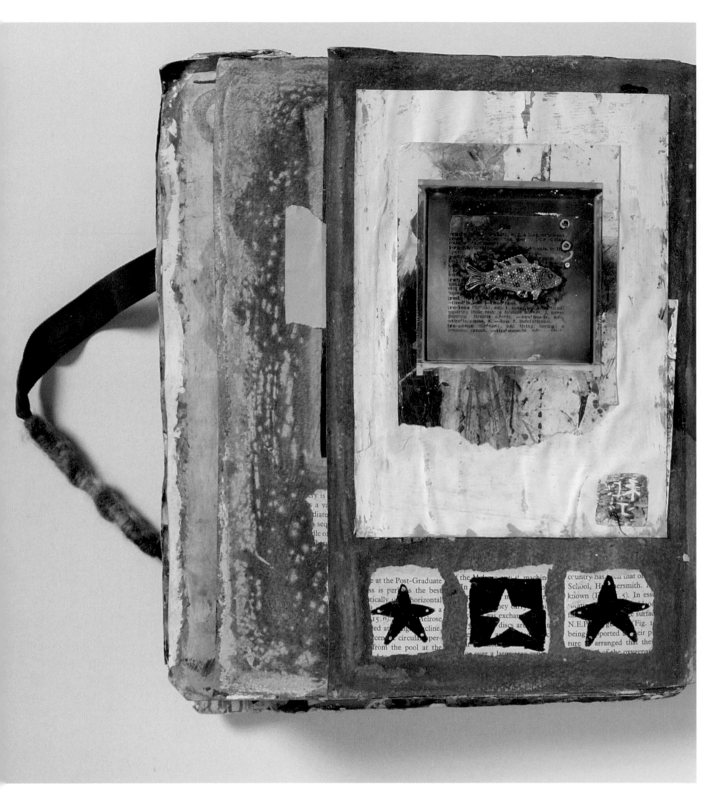

Creating with Refuse

This collage within an art journal was created entirely with discarded papers and an old photograph, proving that sometimes inspiration can come from unlikely sources.

Materials

- discarded papers
- old photographs
- gel medium

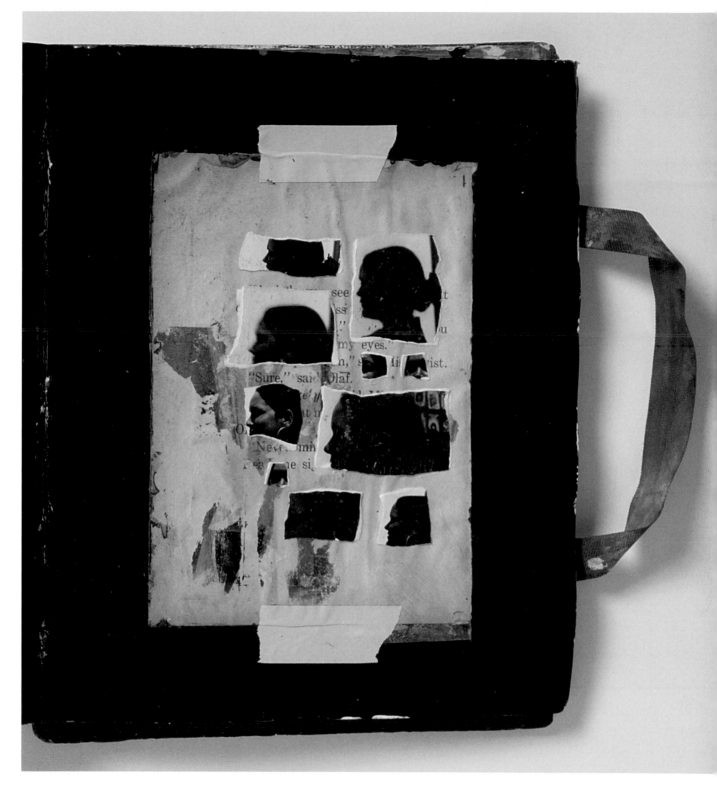

Materials

- book pages
- photographs
- gel medium

Using Old Books and Bad Photographs

Have a favorite book from childhood that has seen its best days? If the book is no longer repairable, use the pages within your altered imagery. The same thing goes for old photographs. Have a bunch of pictures of yourself that you aren't so crazy about? Tear them up, and use only portions of your face within the collage, as seen here. All elements were adhered to the surface using gel medium.

CREATING IMAGE TRANSFERS

Ink-jet transfer images can make wonderful backgrounds for your mixed-media collages.
The following pieces show how transferred images can become part of a larger artwork.

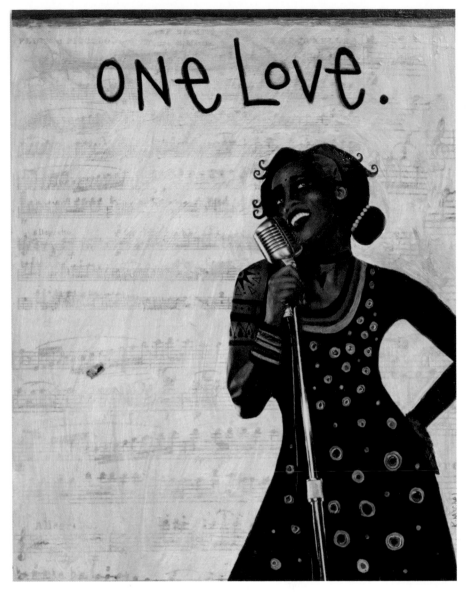

Materials
- sheet music printed in reverse from an ink-jet printer
- gel medium
- canvas board
- acrylic paint
- printed imagery
- gel pens
- gel markers
- faux flower

Using Ink-jet Transfers as Background Imagery

This collage began with a blank canvas board. Sheet music was scanned and printed in reverse from an ink-jet printer. Using the ink-jet transfer method (see page 41), the sheet music was transferred onto the canvas board surface and painted over with a thin layer of yellow acrylic paint, allowing some of the musical notes to peek through. The wonderful form of the singing woman was found in a magazine and completely reworked using gel pens and markers. In the fashion of a coloring book, her clothing, as well as her skin tone; hair; and facial features were colored in and redesigned with gel pens and markers. Her skin and facial features were altered using glazing gel pens, which produce a transparent layer of color that can be built up and blended to create new shadows and highlights, as seen in her face. Gel markers provide an opaque finish, so they were used to color over the original image to revamp her hair and clothing. A faux flower was added to her hair, revisiting the singers from the Big Band era using gel medium. Written in gel marker is the timeless message of "One Love."

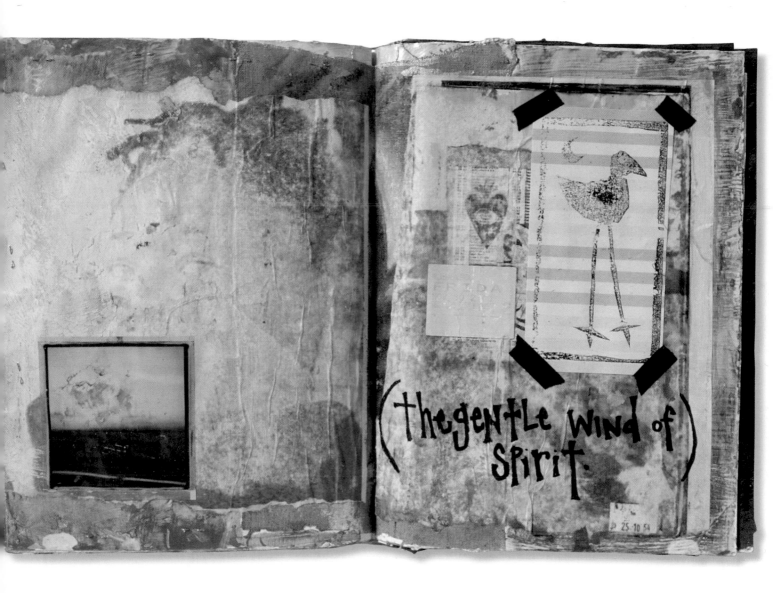

Using Remains from Transfers as Background Imagery

Once an image is transferred onto a desired surface, you are left with a portion of the image remaining on the paper from which it was transferred. As seen in this altered book spread, these remaining images were used to create intriguing backgrounds that were then reworked with photographs and additional paper elements.

Materials

- image remaining on paper after an ink-jet transfer
- gel medium

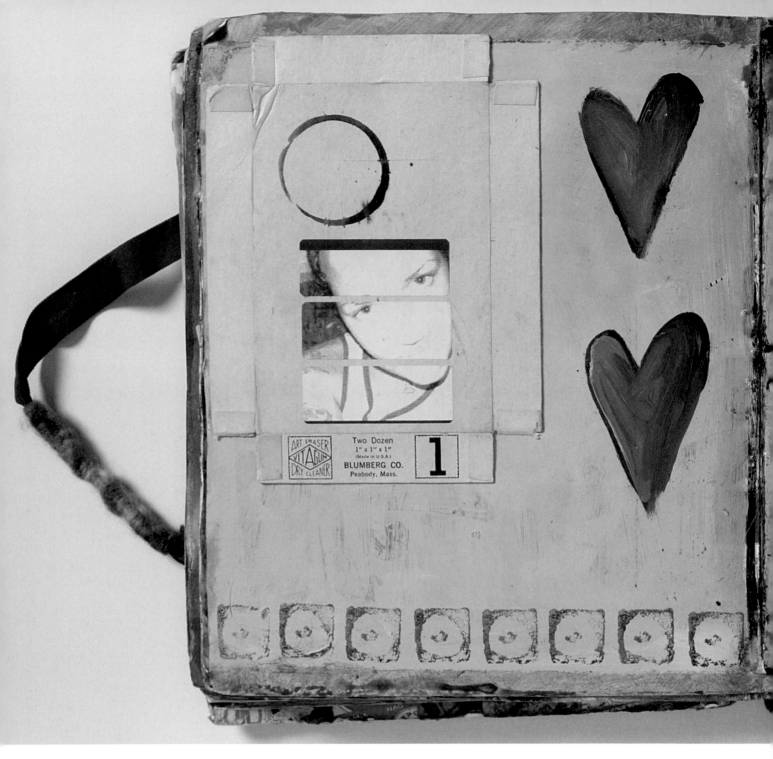

Printing Imagery on Mailing Labels

Printing your images onto self-adhesive mailing labels using your home computer and printer allows you to create an interesting composition with your imagery, as seen in this collage. When printing your image from your computer, replace standard copy paper with a sheet of mailing labels. Add the image to your art by selectively arranging the labels in any order. In this art journal spread, the background was painted with acrylic paints, and a vintage eraser box was glued to the surface, functioning as a frame for the mailing label portrait.

Materials

- image printed onto mailing label sheet from home computer
- acrylic paint
- vintage eraser box
- glue

Materials

- ink-jet image printed on photograph-quality paper
- gel medium
- aluminum tape
- india ink
- vintage coins
- wire
- acrylic paint
- gel pens

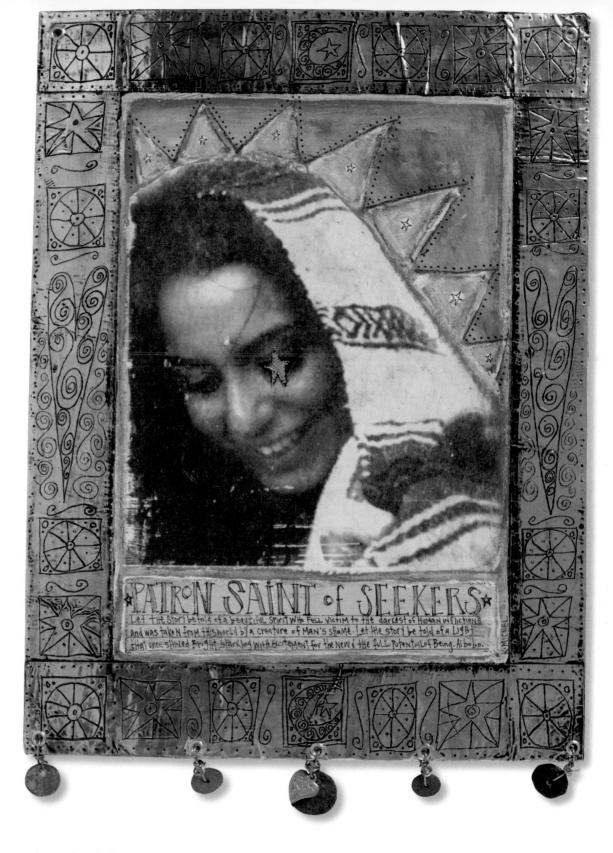

Altered Ink-jet Transfer

Ink-jet transfers (see page 41) work well on canvas boards. In this artwork the image was printed with a high saturation of violet and then transferred onto the surface. The aluminum tape functions as a frame (see page 59) with a selection of vintage coins wrapped with wire around the bottom. The remaining empty space was painted with acrylic paints, with the finer details added using gel pens.

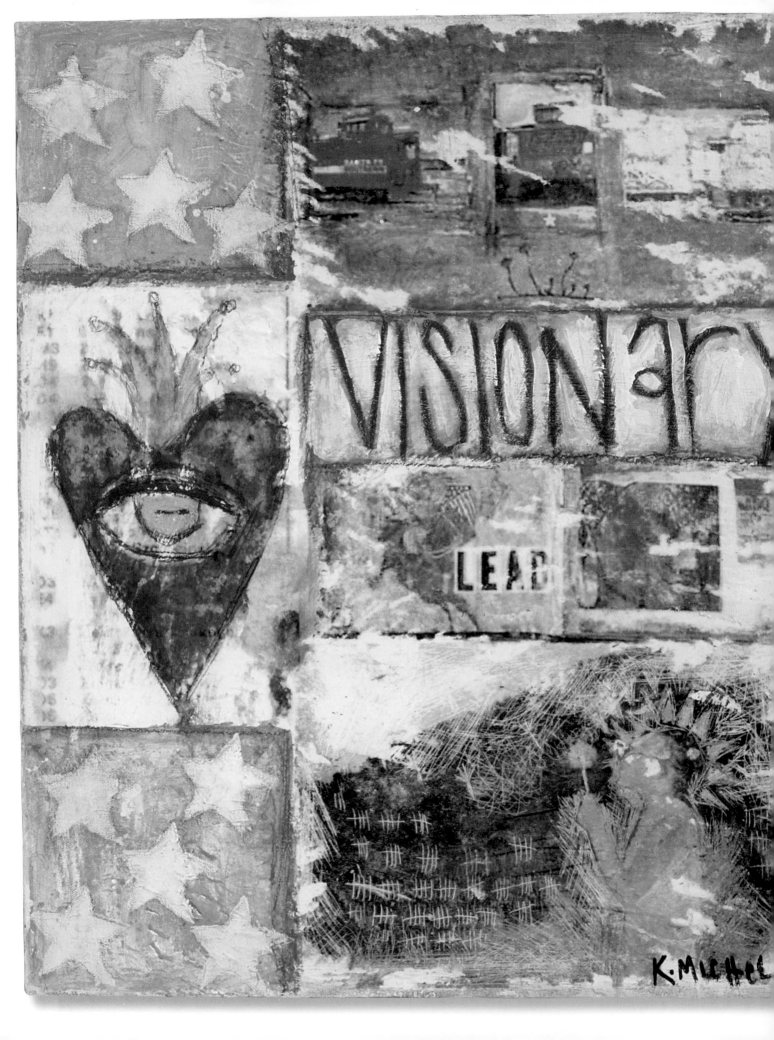

Materials

- selection of images printed from an ink-jet printer on regular 24 lb computer paper
- prestretched canvas
- gel medium
- acrylic paints
- water-soluble oil pastels
- cold wax medium or butcher's wax
- paintbrush
- rag or paper towel

Creating Larger Imagery

In this collage, a selection of images were printed from an ink-jet printer and transferred onto a larger canvas (for more on this transfer process, see page 41). Standard printers limit your prints to 8½" x 11"(21.6 x 27.9 cm), but several prints transferred onto the same surface can create a larger work of art. The areas around the individual transfers were painted with acrylic paints and water-soluble oil pastels.

When transferring ink-jet-produced images from regular 24 lb computer paper, some of the paper pulp may remain on the transferred surface. Scooping a bit of cold wax medium onto a paper towel or rag and blending it over the surface of the transfer will make any remaining paper pulp translucent and will also seal the surface at the same time. Continue to blend the wax into the surface until the image is clear. Made with beeswax, resin, and mineral spirits, cold wax medium is a soft paste formulated to make oil colors thicker and have a more matte finish. It can also be used as a final varnish over a dry painting.

 TIP *Butcher's wax, found in hardware stores, is a good substitute for cold wax medium and will provide similar results.*

...anfangen und meine Freude vollkommen werden.

...en, Schmecken, Fühlen weiche...
...das letzte Tageslicht
...auf dieser Welt erreichen,
...n der Lebens... bricht,
...en JEsum la... nicht. A...en.

...en für...

Monats-Gebet.

...Err! was willst ... soll?

...ch mein... bin ... nunmehr...
...gesta... ... hoch... ... und Gro...en
...es Nachts üb... bekeh...
...aulo, an diese..., mein H...
...Esu! was will... ... ich th... ... Ich weiß w...l,
...as du willst, ... sagt es ... ich soll mich...
...ehren, mich zu di... ... ein neu... ... und ewig
...werden. Ach mein... dieser Herrli...
...elange, so komm... ... mit deiner Gnade entgegen, ...lei...te
...ichrlich, mir mein... ...d, meine ...
...en vo...dein... ... und ni...t...
...Um sei... ... und...
...te ... Anfang der Ber... ... ichd... ...t...e
...nen Willen fahren lasse, und mich all... ...
...richte. Ja mein Heiland, ich mu... du...
...geheiliget wenn...
...ein Antlitz schauen in Gerechtigkeit, ich mu... ... in...
...ild verkläret werden, wenn ich...
...den ... will... ...erb...et

...bekehrter und Verfluchter zur Höllen gewiesen werden. Ach

CHAPTER 4:
ALTERED IMAGERY USING PRINTMAKING TECHNIQUES

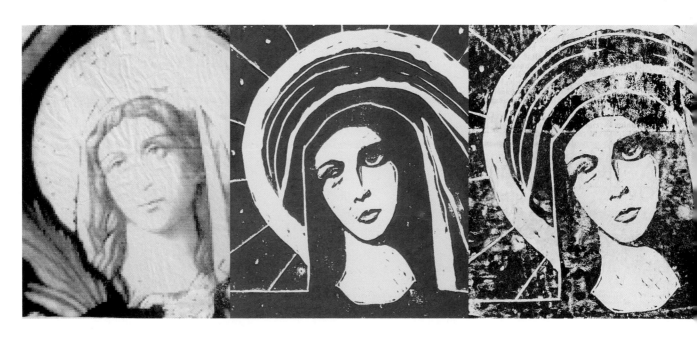

Integrating traditional printmaking techniques into your altered imagery collages can produce multidimensional works of art. You can explore the printmaking process in numerous applications that can create anywhere from one to thousands of prints from one printing plate. Don't be afraid to add new twists to these classic techniques.

USING PRINTED ACETATE AS A NEGATIVE

Traditional photographic methods can be revisited using today's technology. Special transparency film sheets have been created for both ink-jet and laser printers and allow you to create your own negatives in various sizes on your home computer.

To begin, launch your favorite image-editing program, and open the image from which you want to create a negative. There are three steps to print the image as a negative: First, convert the image to grayscale; second, reverse the image (especially if there is text on it); and third, invert the image by making the lights dark and the darks light. All these steps are fairly standard functions in image-editing programs, so explore your program to find these commands in the menus.

TIP

Be sure to follow the directions noted on the special acetate paper when loading your printer so you print the negative on the correct side.

➡ These negatives were printed on an ink-jet printer and trimmed to size.

THE GUM-DICHROMATE PRINTING PROCESS

Noted for its delicate color and painterly characteristics, gumdichromate printing is an alternative photography process that has enjoyed a renaissance due in large part to a photographic movement known as the antiquarian avantgarde. Around since the mid-1800s, this process offers many possibilities for creating photographic prints using various papers and pigments. An easy and forgiving process, all it takes is one sunny afternoon to create numerous prints. Because this process requires that you work with chemicals, be sure to wear gloves and be especially careful not to inhale the fumes. A particle mask is recommended during the mixing process, and you should clean up any spills immediately.

Purchase a kit from a photography supply store that comes with all the chemicals you need premeasured, instead of having to measure the raw chemicals yourself, thereby reducing your exposure to any airborne particles. However, if you choose to mix the ingredients yourself, they are simple: one part gum arabic to one part potassium dichromate solution and your choice of watercolor or tempera pigment.

Before preparing the solution, cover any windows to prevent sunlight coming in and turn off the lights. The room does not need to be completely dark, but you do want to avoid direct sunlight of any kind. Wearing rubber gloves and a face mask, mix the chemicals and add some watercolor or tempera pigment in any color. Experiment with various heavy-weight watercolor papers, but a minimum of 100-lb paper is suggested; sturdy paper that can withstand the washing process. Paint an even layer of the mixture onto your paper and set it to dry, keeping it away from direct light.

When the solution is dry, place the negative on top of the dried solution. Sandwich the paper and the negative between a sheet of cardboard and a sheet of acrylic plastic, such as Plexiglas, to keep the two from sliding around during the printing process. The acrylic plastic sheet should sit flat on top of the negative. Cover the acrylic plastic sheet with a piece of thick, dark fabric and bring it outside in the sun. Pull away the fabric and expose the paper and negative to the sun for approximately one to three minutes, depending on the intensity of the negative. Then cover the paper with the fabric and bring it inside.

Remove the paper from underneath the acrylic plastic sheet and negative and set the paper facedown in a tub of cool water. You can work with the lights on at this point. Wearing rubber gloves, agitate the water slightly and allow the print to soak for approximately five minutes while occasionally checking the developing process. Allow the print to soak off the unnecessary photographic pigment until you are satisfied with the clarity and contrast of the print. Remove the print from the water and set it to dry on a drying rack.

Using this process, experiment on different heavy-weight papers, such as Arches, water-color papers, and canvas-weight fabrics. Using different papers and fabrics and different colored pigments can offer interesting results. With a little trial and error, the possibilities are endless.

Materials

- prepared gum-dichromate solution with magenta pigment
- transparency film negative
- acrylic plastic sheet
- heavy-weight paper
- tub of cool water

⬆ This image is a photo printed from a transparency film negative using the gum-dichromate process with magenta watercolor pigment.

Materials

- prepared gum-dichromate solution with purple pigment
- transparency film negative
- heavy-weight paper
- acrylic plastic sheet
- tub of cool water
- acrylic paint
- images printed from ink-jet printer
- gel medium
- paintbrush

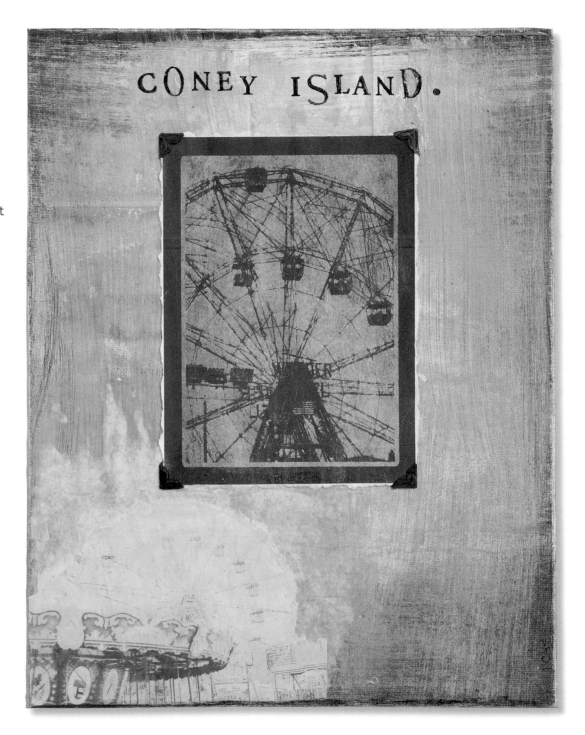

Coney Island Memories

Commemorating Coney Island, the purple image in this piece is a photograph printed from a negative using the gum-dichromate process and purple tempera paint. The background was painted and then worked using ink-jet transfers and paper collage elements showing other Coney Island landmarks. The entire surface was then painted over with yellow acrylic paint, creating a stark contrast next to the photo.

USING PHOTOGRAPHIC IMAGES TO CREATE LINOLEUM AND RUBBER BLOCK PRINTS

Linoleum blocks are a great tool for creating multiple prints of an image. Linoleum sheets, mounted on a background block or unmounted, can be purchased in various sizes. A newer variety of eraserlike rubber blocks are available as well. Like linoleum, they can be carved and used for printing, and they are even a bit easier to cut than linoleum. The printed results from either material are quite similar.

Typically, you carve out the negative space of an image, using linoleum-cutting tools, such as a v-gouge or a u-gouge. After carving, you roll ink over the top and print from the uncarved areas, which constitute the image.

To prepare a specific image that you want to transfer onto the surface of the linoleum or rubber block, make a high-contrast copy of the image that clearly shows your positive and negative space.

Materials

- paper prepared with subtle ink-jet transfers
- carved linoleum printing plate
- printing inks
- wood base
- carpet tacks
- brayer

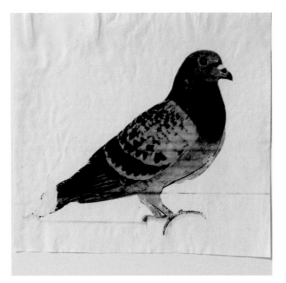
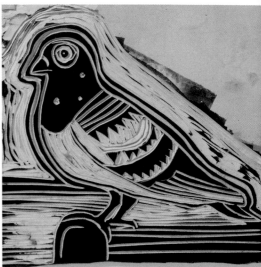

Transferring a Toner Copy

For the softer rubber sheets, transfer a high-contrast toner image (from a laser printer or copy machine) onto the surface by placing the image facedown onto the rubber. Pour a little nail polish remover with acetone onto the back side of the copy and vigorously rub the copy with a smooth object, such as the back side of a spoon. Be careful not to move the copy as you rub. Test the transfer by pulling back the corners of the copy to see if the image is transferring. Add more nail polish remover to the back of the paper as necessary until your image is completely transferred.

Carving the Block

After your image has been transferred, begin to carve your image out of the rubber. All the dark areas should remain and the lighter areas should be removed. As you carve, push the tool away from your hands—these tools are very sharp and can do serious damage. You do not need to be strict about the actual form of the transferred image—feel free to reinterpret the form. When you are satisfied with the carved-out image, squeeze some block-printing ink (oil or acrylic) onto a sheet of acrylic plastic. Roll the ink evenly onto a brayer, and apply the ink to your printing block.

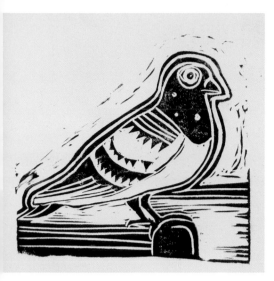

Making the Print

After the printing block is completely inked, place a sheet of paper over it and rub the back side of the paper from top to bottom using a burnishing tool or wooden spoon, applying even pressure throughout. Gently peel the paper off the block, and set the print to dry. Be sure to clean your carved printing block when you are finished printing. For acrylic inks, simply run the entire rubber sheet under warm water. For oil-based inks, use a rag with turpentine.

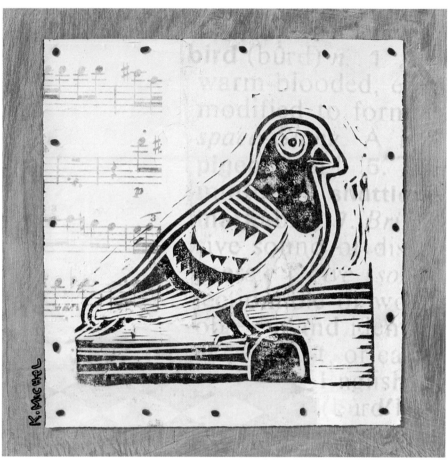

Printing over Transfer Images

For this print, the paper was prepared with a series of ink-jet transfers before the image was printed onto the surface. The finished piece was then mounted onto wood using carpet tacks for a bold effect.

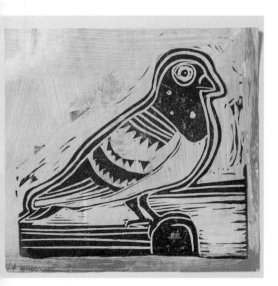

Printing over a Painted Surface

Continue to experiment by printing onto various surfaces and papers. For this print, the paper was prepared with paint before the image was printed onto the surface.

Transferring Images to Linoleum

Unmounted linoleum is a bit stiffer than the rubber blocks and less porous. To transfer your image, use the same procedure that you used to transfer an image onto the rubber block (see page 76).

Materials:

- paper prepared with subtle ink-jet transfers
- carved linoleum printing plate
- printing inks
- wood base (any type of wood will do)
- carpet tacks
- brayer

⬆ Ink-jet copy sample

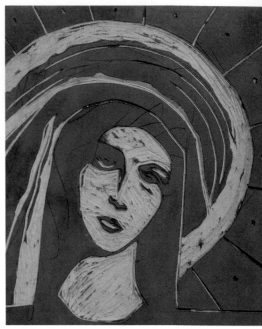

⬆ Carved linoleum printing block

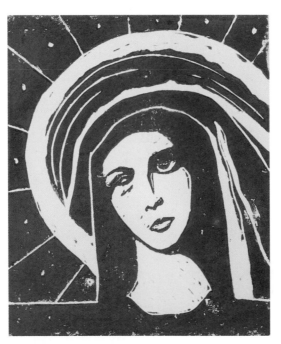

⬆ Linoleum print created using blue block-printing ink

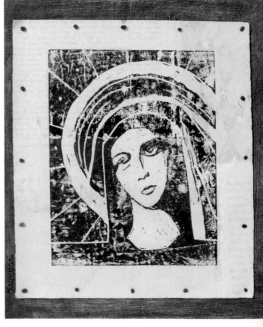

⬆ For this print, the paper was prepared with a series of ink-jet transfers before the image was printed onto the surface. The finished piece was then mounted onto wood using carpet tacks for a bold effect.

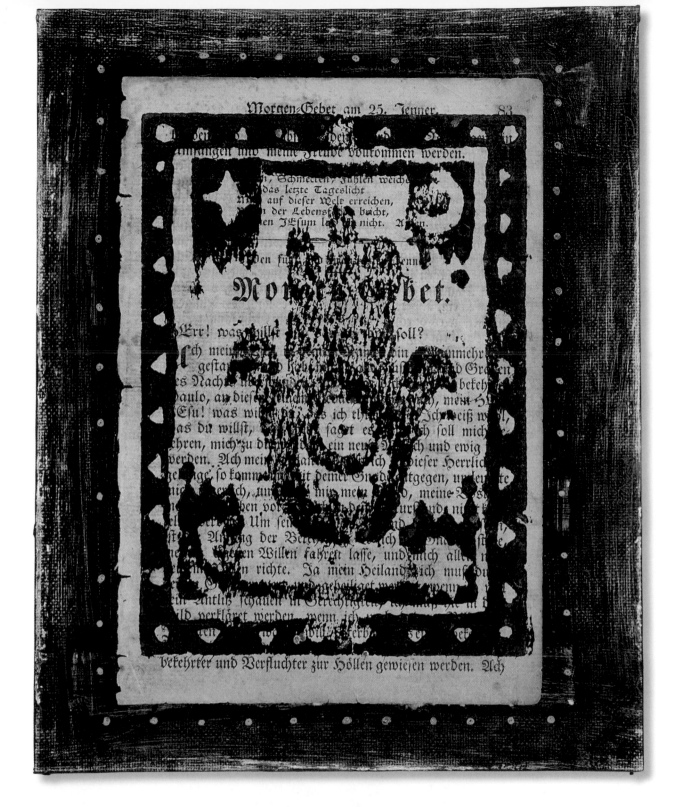

Materials

- old book page
- carved linoleum printing plate
- printing inks
- canvas board
- paint
- gel pens
- gel medium
- brayer

⬆ Old book pages make an interesting background for your prints. In this piece, the print was made from a linoleum print onto an old book page. The print was then mounted onto a canvas board with gel medium where the background was embellished with paint and gel pens.

CREATING MONOPRINTS

Monoprinting is a form of printmaking that creates just one print from the printing plate. One benefit of monoprinting is that no special equipment is necessary. The basic tools required are block-printing inks (acrylic or oil-based) or paints, a sheet of acetate or plastic, and a brayer or roller. It is an improvisational process with few rights or wrongs.

To begin, using a paintbrush and printing inks (or paints) begin painting directly onto the acrylic plastic or plastic sheet. You can place an image underneath the plastic to use as a guide. Remember that the painting will print in reverse, so if you are integrating text into your composition, you will need to paint it backward. When you have completed the painting, lightly dampen a piece of paper by spritzing it with water. (A simple spray bottle filled with water works perfectly.) Place the paper over the painted sheet and use the brayer or your hand to apply even pressure over the backside of the paper. Peel the paper off the plate, and set your print to dry. You can clean the printing plate and repeat this process until you are satisfied with your result. You can rework the surface as many times as needed and continue to experiment with the process by printing on various types of paper or even on collaged surfaces.

MONOPRINTING OVER A COLLAGE

This monoprint (right) is printed over a collaged background. To subdue the imagery in the collage, a thin layer of gesso was painted over the entire page, rubbed off, and then set to dry. To create the heart shapes, masking tape was used to mask and protect the areas from the printing plate. To create large masking-tape shapes for blocking out areas in your prints, take a sheet of wax paper and cover it with masking tape. Be sure to slightly overlap each strip of masking tape. Cut your shapes from the wax paper/masking tape sheets, and then peel the wax paper off the back of the masking tape. Place the shape on the surface onto which you will be printing, being sure to remove all air bubbles.

For collaged backgrounds where the surface may not be level throughout, painting your monoprint on a sheet of acetate is a good idea because it is more flexible than acrylic plastic or stiff plastic. Ink or paint the surface of the acetate and then place it on top of your collage, using your hands to press firmly over the entire surface. You can repeat this process as many times as needed. When you are finished printing, peel off the masking tape to reveal the masked forms underneath.

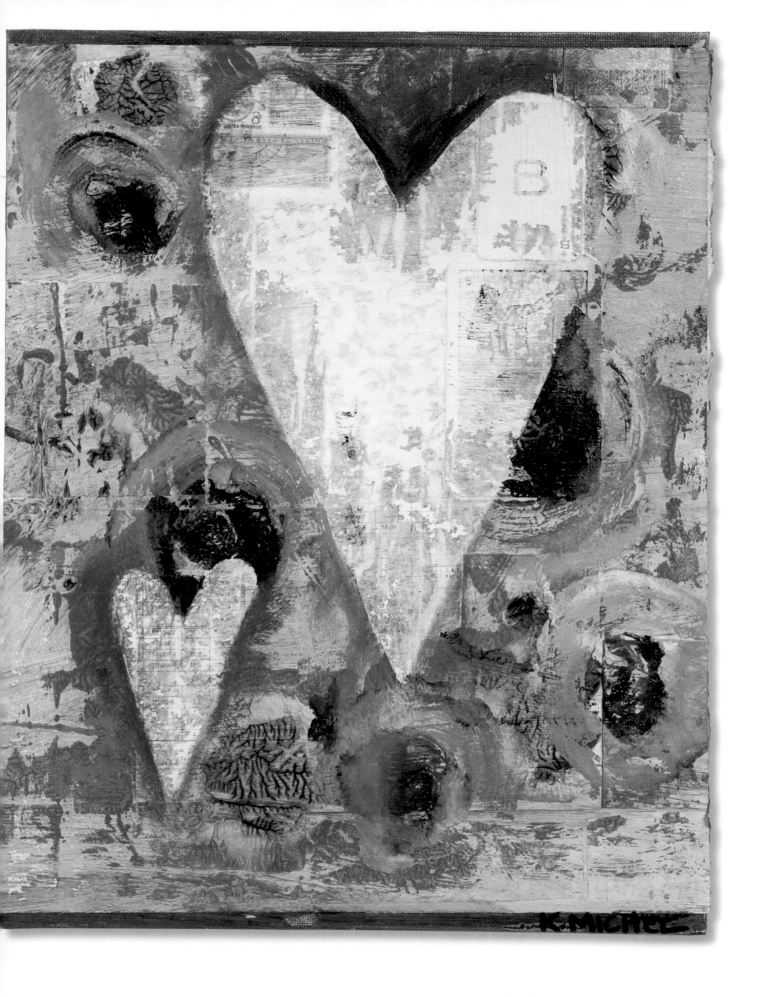

K·MICHAE

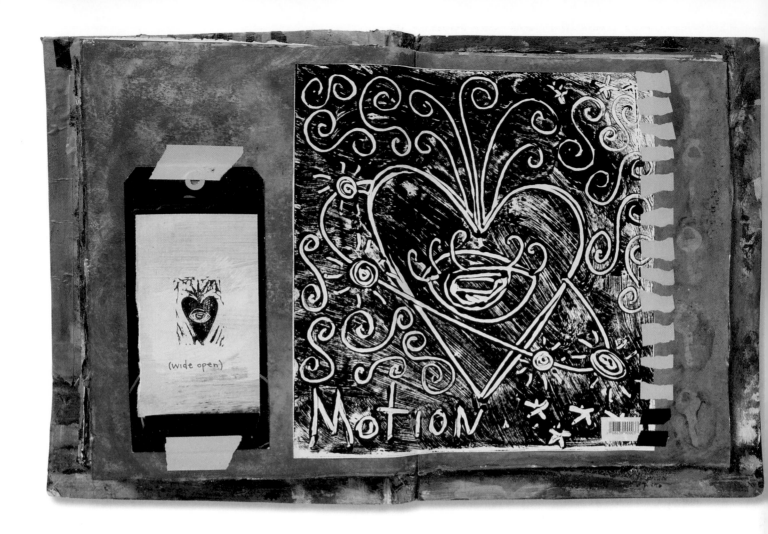

MONOPRINT REVERSE TECHNIQUE

Another approach to monoprinting is to work in reverse by covering the printing plate completely with ink and then removing the ink to create your composition. Using your brayer or roller, spread a layer of ink onto the plate and then draw directly onto the plate by removing ink with cotton swabs or rags. This print was created by doing a freeform sketch onto the ink plate using a cotton swab. After the print was created, it was glued into an art journal.

For textural effects, you can also remove the ink with brushes, feathers, sticks, or any other object that creates an interesting mark.

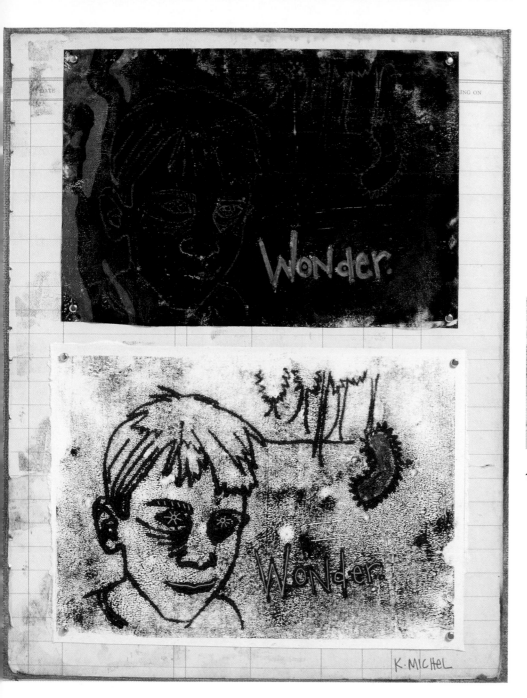

↑ Photograph sample, basis for print to the left

This reverse monoprint was created by inking a sheet of acetate and placing it on top of a sheet of paper (ink side down). A photograph was then placed on top of the acetate, and the outlines of the image on the photograph were sketched on top of the photograph using a pencil. The impressions from the pencil transferred the ink from the acetate onto the paper below. Once the sketch from the photograph was complete, the acetate was peeled from the paper underneath and what remained was a print of the sketch. Once dried, the print was further embellished with gel pens and markers.

⬆ Photograph sample, basis for print at right.

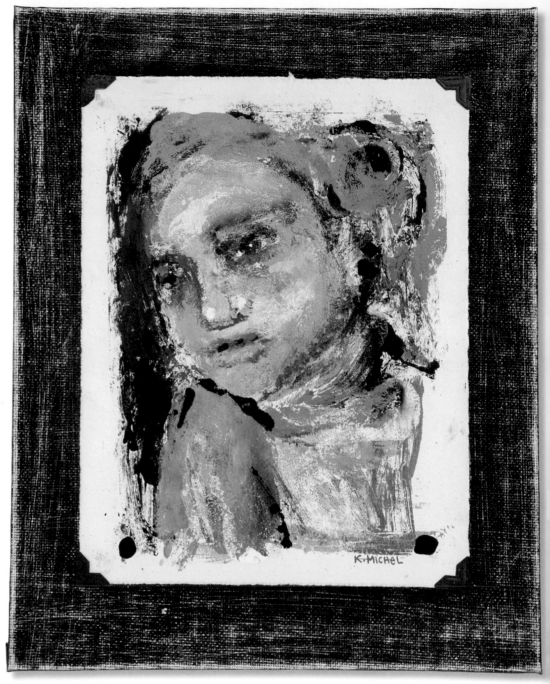

MONOPRINT FROM A PHOTO

This monoprint was created using a photograph as a reference. The plastic plate was placed over the photograph to use as a guide, and the figure was "sketched" onto the plate with printing inks. Each color was worked on the plate independently, printed, and then repeated, building up the colored layers. The result is a painterly, somber version of the original image.

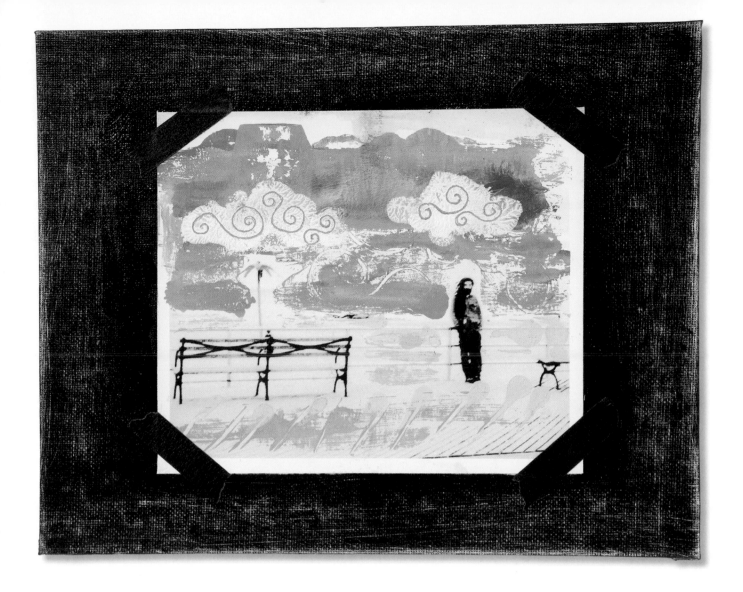

MONOPRINT OVER A PHOTO

To create a monoprint over a photo, it is helpful to have a reversed copy of your photograph handy. Using the reversed copy, place a sheet of plastic over the image and begin painting in areas of the photograph that you would like to alter with the print. Remember that this process can be repeated as many times as needed, so you may want to start with more subtle markings. Once your plastic is inked or painted, print it directly over your image. In this print, the process was performed over a digital photograph printed onto ink-jet photographic paper, enhancing the sky and bits of the sand and boardwalk. The clouds were reworked using a gel pen to create some finer marks to finish it off.

PRINTING OVER PHOTOS

All the previous processes can be explored over photographs and digital prints. Feel free to continue exploring all the processes independently as well as in combinations with each other. There are no set formulas that you must follow—just continue to experiment and discover what works best for you.

FUN IDEAS FOR DEVELOPING YOUR CREATIVE SELF

1. Keep an art journal or sketchbook. The daily creative practice of creating art within the pages will strengthen your artistic voice.

2. Create self-portraits—what better model do you have to work with than yourself? Don't be shy: Photograph yourself, sketch yourself in the mirror, and explore the inner you.

3. If you don't have an outside studio for your art, designate an area of your home to be your creative sanctuary. Be it a spare bedroom or even a table in a corner, having an area you can go to and get busy will inspire you to get creative.

4. Save horoscopes from newspapers for interesting words to use in your art.

5. Take some photographic portraits of your worn or used art supplies for use in your art.

6. Create an altered-book travel album! Have you traveled to Mexico, or maybe Europe? Buy an old hardcover book about that country or even a travel guide to add your altered travel photographs to the pages.

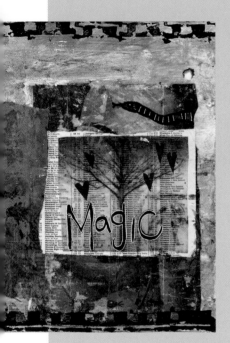

7. Need a reason to buy chocolate? How about for the colored foil wrappers that are fun additions to collage. Keep your eyes open during the holidays—that's when you'll find the really vibrant colors!

8. Take photographs or create portraits of your loved ones' hands and alter them.

9. Take a trip to the hardware store with art supplies in mind. You never know what treasures you might find on the shelves.

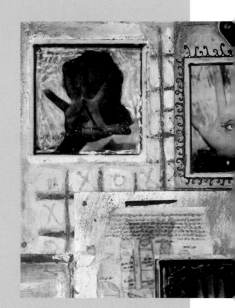

10. Invite a small group of friends over for an art party. Buy an inexpensive plastic table cover, whip out the art supplies, and have fun!

11. Plan a day to explore the art galleries and museums in your area. And don't forget your sketchbook to capture the inspiration.

12. Carve an alphabet stamp set—buy a box of square erasers and design your own font for use in your art.

CHAPTER 5:
PROJECT GALLERY

Artist: Monica Riffe

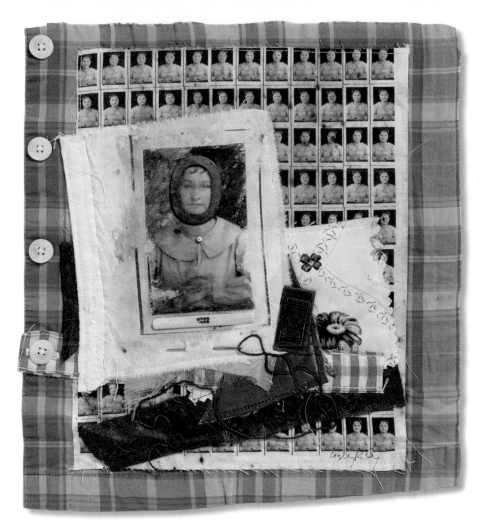

ARTIST'S TIP

Transferring images onto fabric has a more artistic and timeworn look to it than printing directly onto fabric. It alters the edges and colors of the image and blurs the connection between space and time.

FRAGMENTS: IMAGE TRANSFERS AND FABRIC COLLAGE
ARTIST: Lesley Riley

Lesley Riley came across this vintage photograph of a woman (above) and thought that the subject's gaze and expression were so full of stories that she wanted to give her a place to tell them. The original photograph was scanned into Photoshop. She created a background fabric using the photo by reducing and repeating the image so that it had the appearance of a checked background. This was then printed onto fabric.

She printed another, larger version of the photograph onto an ink-jet transparency and transferred it using golden matte medium on a coffee-stained and aged piece of muslin. The images were then combined with other fabrics and found objects to complete the collage.

The artist finds most of her images on eBay. She used to find them at estate sales and antique or junk shops, but using the Internet to find photographs affords her more time in the studio. She only uses a photograph if it first speaks to her. Then she can use her voice and her style along with the image to speak to the viewer.

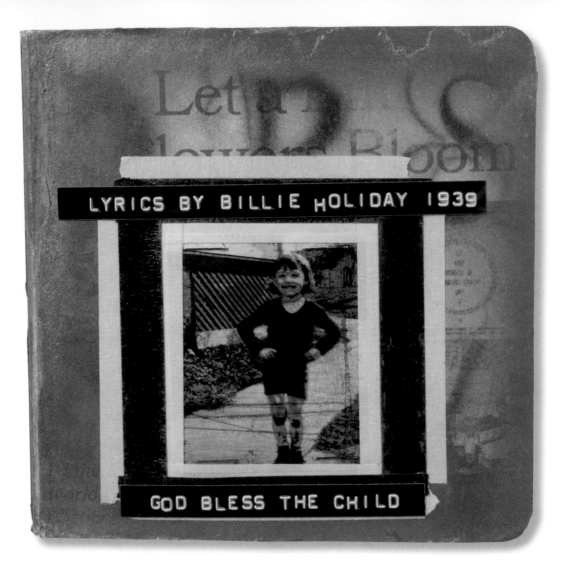

GOD BLESS THE CHILD
ARTIST: Sarah Fishburn

Sarah Fishburn is working on a series of board books based on either poems or songs, excerpted or in their entirety. This is one in her series, based on "God Bless the Child", originally recorded in 1939 by Billie Holiday. Her admiration of Holiday's music knows no bounds. In a few short lines, "God Bless the Child" totally describes human nature and the contradictory nature of life within the framework of a need and desire for independence and the simultaneous need for support. The song is a deceptively simple work of genius.

The newspaper background was altered and embellished with spraypaint and stencils, then layered with metallic pigment. Her photographs (and for this book, one rubber-stamp image) were color-altered in Photoshop and then the images were posterized. She printed them onto transparency acetate and collaged beneath them.

Sarah uses family photographs whenever she can. The cover photograph for this book is her "mum," as is one of the inside photographs. The back photograph is the artist. She also uses found photographs, vintage postcards, and occasionally, stock images and rubber stamps.

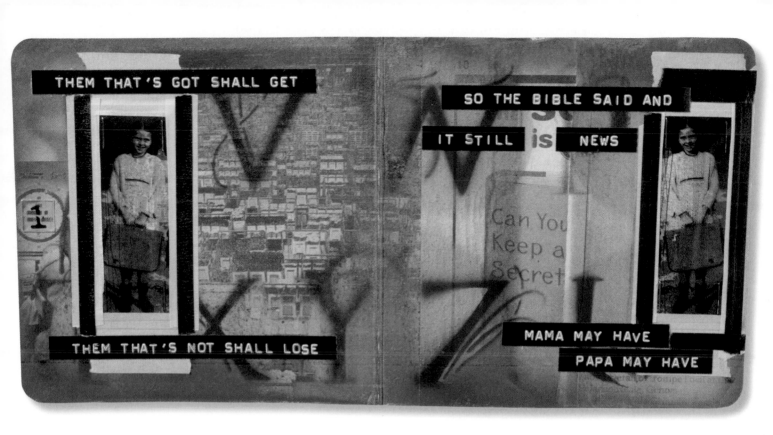

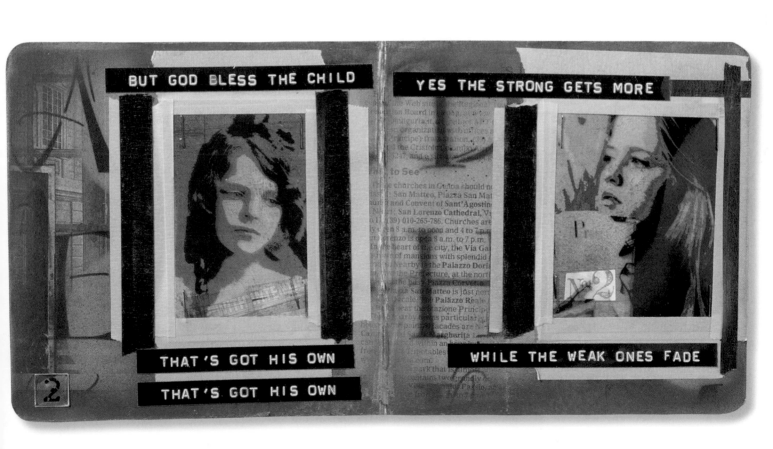

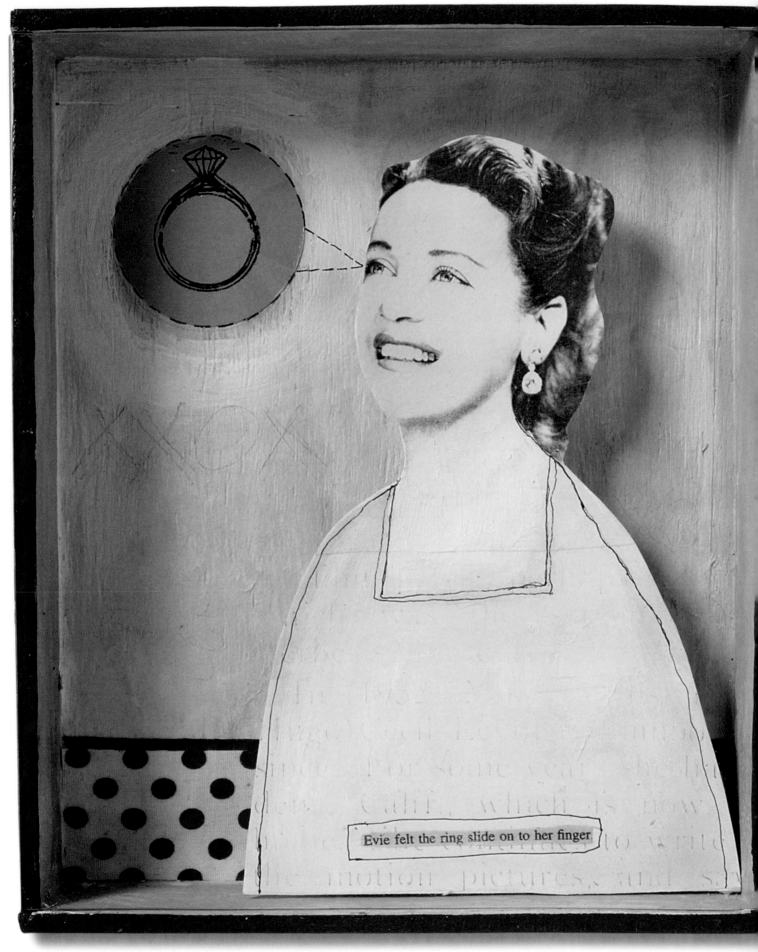

Evie felt the ring slide on to her finger

EVIE
ARTIST: Claudine Hellmuth

This piece is a tongue-in-cheek piece about weddings. It is about women who are so caught up in the idea of a wedding that to them it doesn't matter who they are marrying or what the actual marriage will be like—it's about the ring and wedding and all the trimmings. She found the phrase "Evie felt the ring slide on to her finger" in an old romance novel. After cutting it out, she happened across an image of a woman who looks as if she is a beauty queen. The artist thought she could depict the woman dreaming of an engagement ring. She used an old cigar box, removed the lid, and painted it. She then cut acrylic plastic to fit the box and transferred a photocopied image of a ring to the back of it.

After finding the Evie image, Claudine made a black-and-white photocopy of the original photo and glued it to watercolor paper using gel medium to stiffen the surface. She painted the photocopy with titan buff acrylic paint to add a little color and also added line drawing using pen and ink. She glued the text to the lower part of Evie's torso and added small wooden blocks to the back of the image so that it could be glued into the box and add dimension.

Claudine has collected various photographs and images over the years from antique shops, estate sales, and eBay. She usually buys collage supplies from eBay so she can make art rather than spend time shopping!

ARTIST'S TIPS

A fun way to generate an idea: Pull quotes out of silly thrift-store romance novels.

Using a black-and-white photocopy, you can transfer the image to acrylic plastic or glass with a heat-transfer tool. You can use any wood-burning tool with a flat head. Place your image facedown on the plastic or glass and rub the back of the image with the heat tool. Make sure to plug in your tool and start applying pressure to the back of the copy right away before it heats up. This way if you allow the tool to heat up on the glass slowly, you won't crack it or make burn marks on it. After a few minutes, your image will be transferred. If any paper sticks to the surface, simply wet the paper to rub off. This transfer method does not reverse your words or images because you are transferring to the back of the glass.

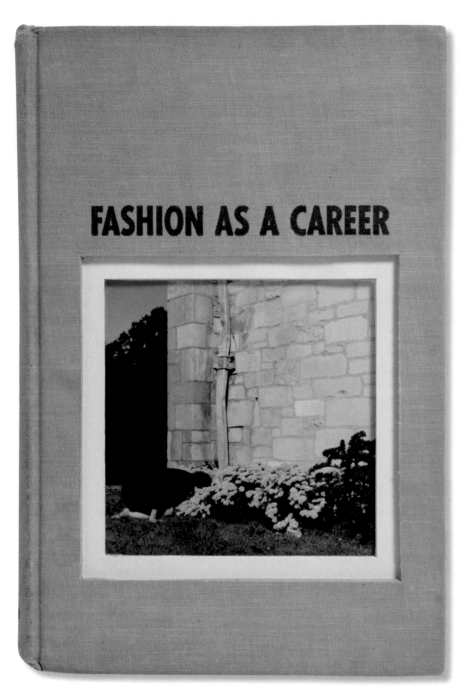

FASHION AS A CAREER
ARTIST: Dana Gentile

This piece is one in an ongoing series of altered books. The series began as an effort by the artist to make art objects that viewers can pick up, touch, and interact with, thereby challenging the viewer's ideas about how stories and art can be presented and received.

By binding a photographic print into an antique book, Dana ensured that the image is viewed differently than if it were shown traditionally in a frame hanging on a wall. A portion of the book's front cover and some of its pages have been cut away so the image looks as if it belongs in the book; the image is revealed rather than presented. Incorporating text from the book, the artist made the book a nontraditional frame for the photograph, forcing the viewer to read the image in a certain context.

Dana takes her own photographs for her artwork.

MAP OF A MINUTE
ARTIST: Shirley Ende-Saxe

The artist took some papers with her to Monica Riffe's cabin in the Rockies the previous summer, and spent an afternoon with paper and paint. They began trading things, and before long a Rocky Mountain Parks brochure, Asian papers, and hole reinforcements adorned Shirley's painted paper. Monica also had some old typewriter ribbon that Shirley used to draw red and blue scribbles. When they finished, there was a large negative space in the center, very mysterious and empty, and she took it home, feeling it was complete.

At home, it aged. Two weeks later the old photograph of friends and cut-out house shape found their way to the clutter on her table. They belonged in the space, so she put them there, reminding her of the trip: two friends in the shelter of a house. The principal technique used to alter the images was creating layers of acrylic paint—applied and then lifted—along with cutting, tearing, and collage. The photograph was painted over and cut.

This artist believes we're all buried in images; they're cheap and overwhelmingly common. Her favorite sources are worn or throwaway kinds: brochures, maps, magazines, and old photographs. She never copies an image to use it repeatedly because she doesn't worry about finding others. Friends give her photographs, and she uses her own or purchases cheap ones at flea markets. She doesn't need anything unusual because just cutting a shape into it gives the basic illusion of photography. And that's unusual enough.

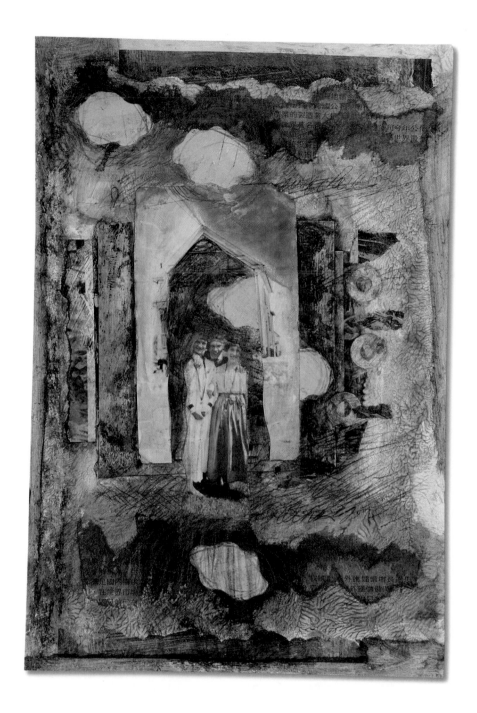

ARTIST'S TIP

Inspiration is slippery. When the burning desire to create or express is absent, sitting down with images and moving them around in little groups is enough to help get a grip on what needs to be done. Put one with another, and pretty soon they're asking for another to join them. The images themselves can create the inspiration, but cutting and pushing things together helps, too.

COLLAGE PAINTING
ARTIST: Monica Riffe

The artist created this collaged painting in the June 2004 Santa Fe workshop taught by Lynne Perrella.

Lynne provided the red rosin paper. Its common use is to protect floors during building construction, but she cleverly adapted it as an inexpensive but sturdy ground for paintings. Because of its nonprecious quality, it relieves an artist of any anxiety over working in a large format. It eliminates the intimidating quality of a blank canvas.

To prepare the paper for painting, Monica covered it with gesso. She took the liberty of embedding items in the gesso—a postcard, some rose petals, and paint chips. She liked the way these randomly placed bits of material added interest and texture or defined a space in the final painting.

Workshop attendees had been asked to bring a few photocopied images for possible inclusion in their work. Among other bits gleaned from her studio, the artist brought a photocopy of a raven that she had used in another artwork. From that image, she made a large and small stencil. She repeated them as negative and positive images, applying paint on the stencil itself, sponging paint inside the stencil, or reversing the direction of the stencil for interest.

As she worked on this piece, the Joan Baez song, "Gracias a la Vida," ran through her mind. In Spanish, the title means "thanks for life." In a stream-of-consciousness painting moment, she decided to include these words on the page. She was also thinking about Edgar Allan Poe's raven and the line, "...quoth the Raven, 'Nevermore,'" and thought, if the raven in her work could speak, it would say, "MORE!"—more life, more aliveness. Therefore, she stenciled the ampersand over the raven to symbolize "MORE".

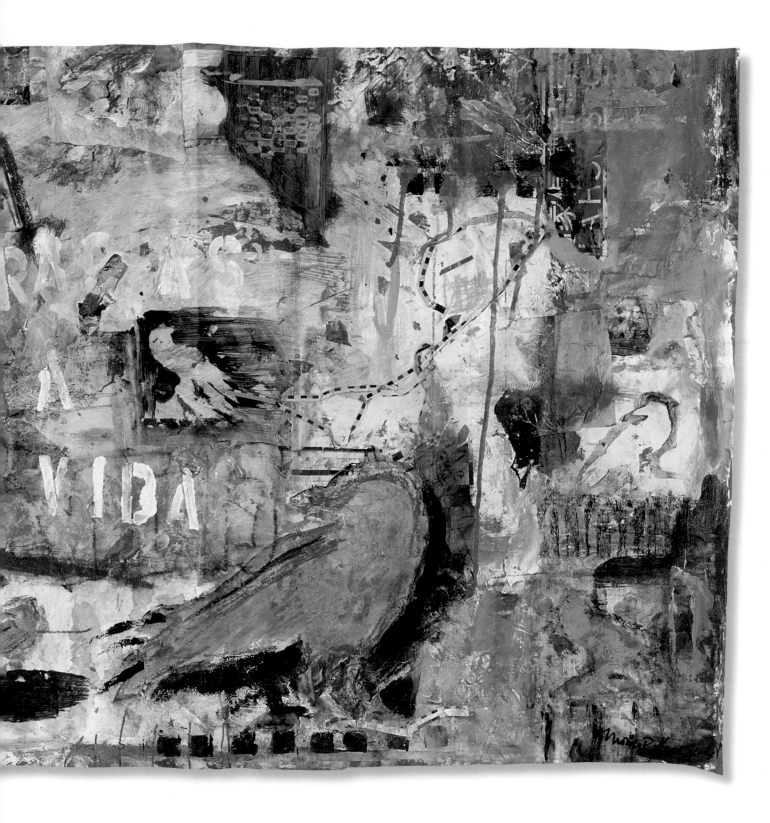

ARTIST'S TIP *Many ideas come from your internal chatter. The trick is to listen and respond.*

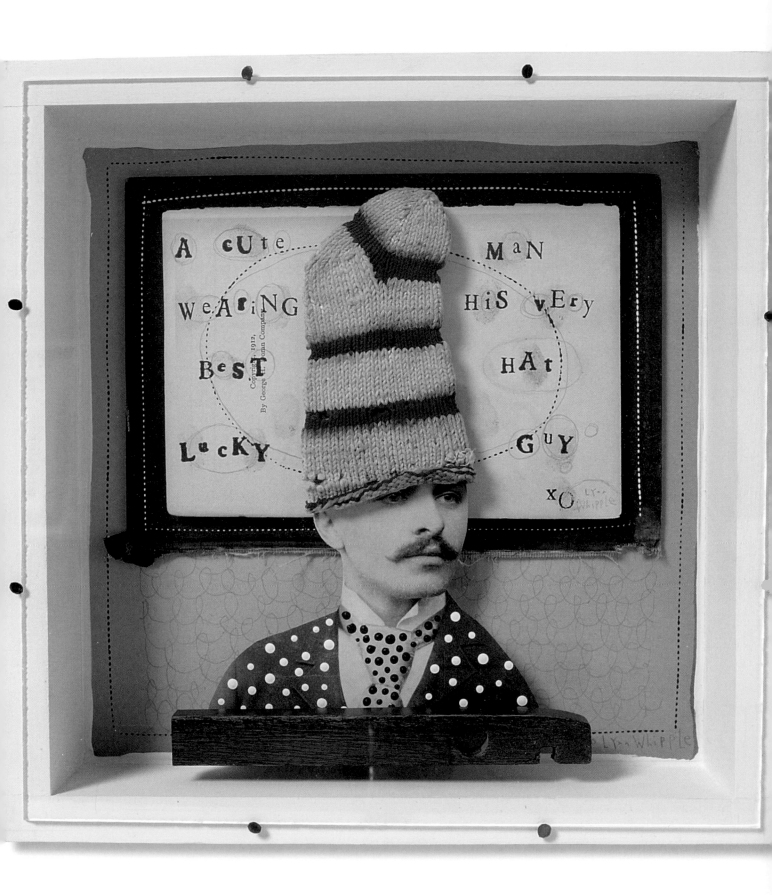

The words in the collage read:

A cUte MaN weAriNg HiS vEry BeST HAt LucKY GuY xO

Copyright, 1912,
By George Matthews Adams Company

Lynn Whipple

LUCKY HAT
ARTIST: Lynn Whipple

The inspiration for this piece came from a pair of children's wonderful wool red-and-white striped socks that the artist's husband found at an antique shop. She was not sure how to work with them at first, and they just hung around the studio for a while. In the process of playing one day, she turned the sock upside down, and voilà! They became a funny hat! Now she had a jumping-off point to create this "Ninny Box" (what she calls her signature mixed-media assemblage collages).

Taking an old photograph of a good-looking fellow, Lynn enlarged it and cut it out to make sure the "hat" would fit his head. Once the size was right, she was able to work on altering the photo. She chose to simply decorate his jacket with spots of white acrylic paint and his tie with spots of red acrylic paint. It was the striped-sock hat that had made all the difference.

She is a longtime collector of images and owns well over 5,000 old photographs. She keeps collecting, however, because they are a constant source of fascination. The amazing way a picture tells a story combined with the information that the artist can add create a perfect opportunity for imagination exploration.

ARTIST'S TIP

My method of working has always been that of an explorer. I love collecting odd bits and found objects and putting them together in a way that seems new or different. My inspiration comes from surrounding myself with these interesting things and seeing what comes together. I am a firm believer in happy accidents and am willing not to know how something is going to turn out for the joy of the progress. Exploring in a way that nourishes your imagination will foster your growth as an artist.

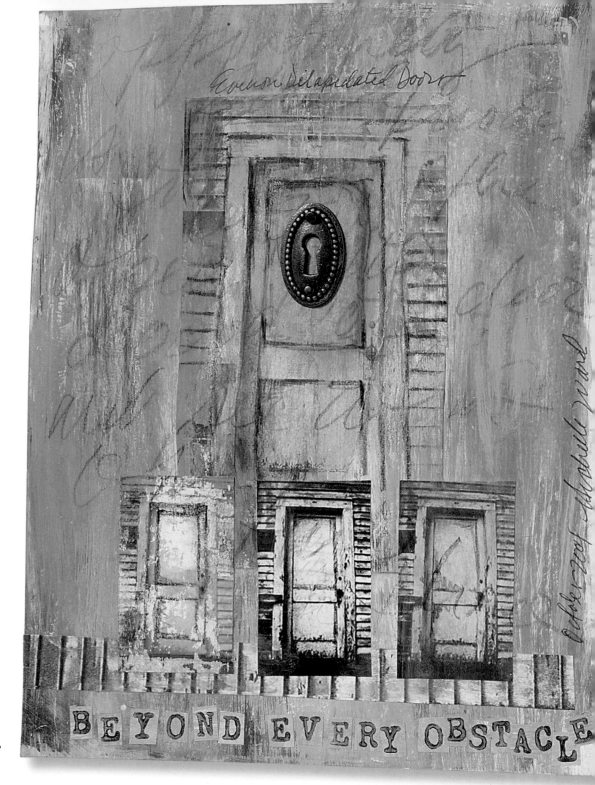

ARTIST JOURNAL
Michelle Ward

These journal pages are an example of exercises that Michelle uses to prompt herself to try new things with imagery. The inspiration came directly from the original photo (left), where the siding of the house was a wonderful peeling paint, revealing layers of previous colors of sage, yellow, and gray. The photograph of the door was taken by the artist with a digital camera. It's from a house in Port Townsend, Washington.

For the larger doors shown in the journal, she made photocopies of the photograph for several toner transfers using xylene. The transferred images were layered to create the door. For the smaller doors, she used the photograph reduced for ink-jet transfers and painted photocopies.

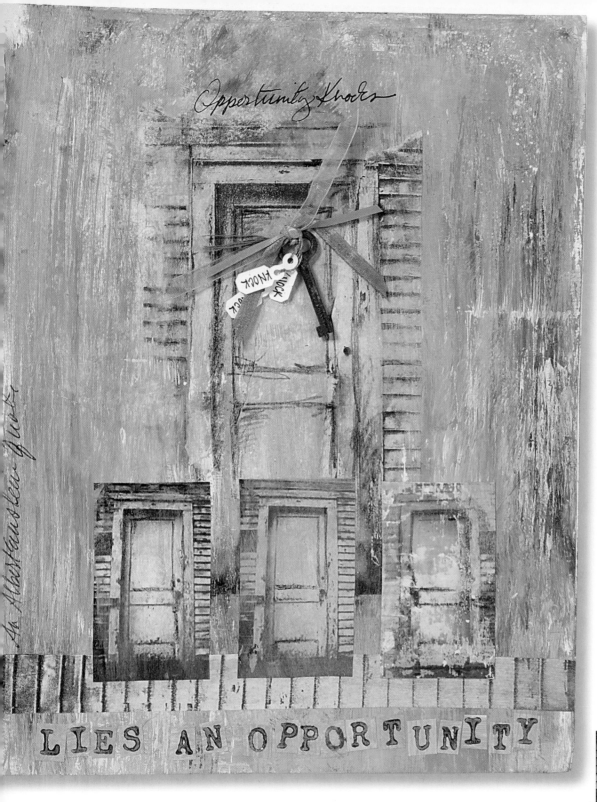

Opportunity Knocks

An Ahistanslea finite

KNOCK KNOCK

LIES AN OPPORTUNITY

ARTIST'S TIP

I used to think that if you painted over a photocopy you would lose the image. However, I discovered that if you spray water on a painted photocopy, you can wipe away the heaviness of the paint, leaving a trace of color while keeping the image intact.

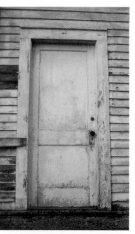

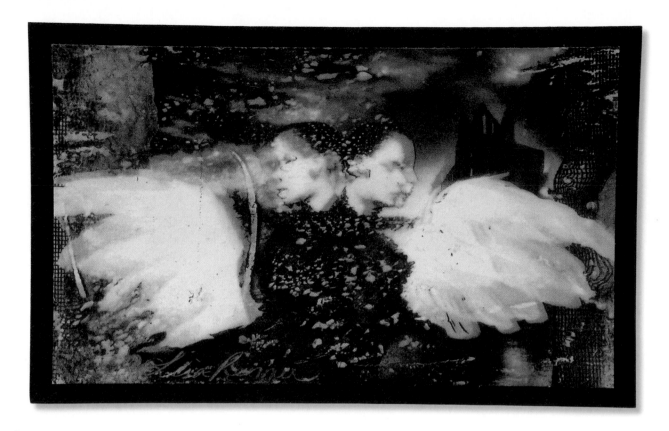

IMAGE TRANSFER COLLAGE
ARTIST: Lisa Renner

This transparency-film image transfer (above) of an original collage (right) using gel medium is actually the result of a mistake. It started as an image transfer, gone awry, of a card the artist had designed for a collaborative Halloween deck project hosted by Red Dog Scott.

Lisa made a collage using handmade textural backgrounds, feathered wings, and images cut from various photographs and magazines. The dark background is from a photograph of a haunted-looking house on a lake. The wings are actual feathers. The brown, textural background is one she teaches in one of her classes using paints and texture medium. She copied the finished collage onto a sheet of transparency film on an ink-jet color copier. She then used adhesive on the receiving paper, pressed the transparency film on top, and burnished the film with a paper towel. Normally, when the film is removed, the medium transfers the image from the film to the receiving paper. But as soon as she pressed the film down, she realized she used too much medium, because the image had started to smear underneath the film and became slightly distorted. She thought she would remove the film to see if she could salvage the piece. When she started to lift the film off the receiving paper, she accidentally shifted it to the left, dragging the image with it, causing the ghostly effect. She really liked it, so she left the film in place to preserve her "mistake."

Vintage photographs are always a good source of imagery, as are personal photographs. She likes to use transparency overlays to alter and enhance her collage elements.

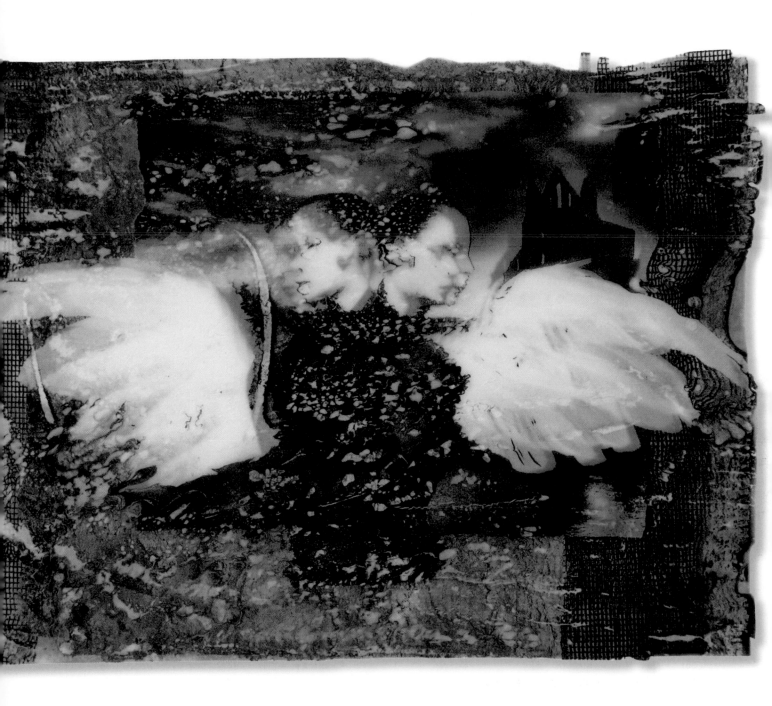

ARTIST'S TIP

Be aware of all you see around yourself as a potential source for fresh ideas in your art. Fashion magazines use a stimulating blend of color and style. Movie trailers offer fast-paced and visually appealing imagery. Commercials, billboards, and jewelry and bead shows offer an array of beautiful colors and textures that can inspire. Also, visit home decor stores, toy stores, fabric stores, art galleries, and antique stores. Look for unusual things on the ground if you go for a walk. Sometimes even listening to music can send you off on a creative tangent.

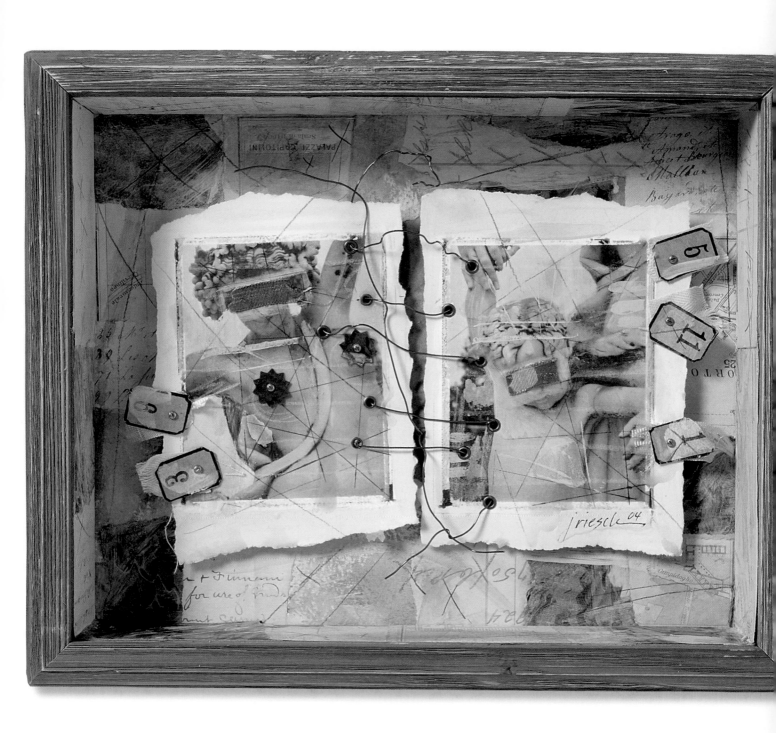

SHADOW BOX
ARTIST: Judi Riesch

This shadow box holds two Polaroid image transfers made from slides that Judi took at the Biltmore Estate in Asheville, North Carolina. She was inspired by the breathtaking century-old gardens and the lovely classic statuary.

After creating the image transfers from slides using a slide printer, Judi layered paints, stenciling, pencils, crayons, vintage papers and trims, and beeswax to alter the surface. The images are connected with wire and "suspended" on the background.

All the Polaroid transfers she makes are from her own slides. She photographs statuary and architectural images, as well as some of her own assemblages. Judi also has an extensive collection of vintage photographs that constantly inspire her.

The soft painterly feel of a Polaroid transfer lends itself well to manipulation. She often uses various sharp tools to scratch the surface of the emulsion while it is still wet, before adding layers of additional materials.

ARTIST'S TIP

Use iconic images (such as vintage paintings) and then provide a new twist—in this case, I liked the idea of posterizing the image, plus changing the color palette to something vivid and contemporary. The play of old and new is a commentary of how classic works of art remain valuable and viable and provide endless opportunities to manipulate and "harvest" the images.

MIXED-MEDIA COLLAGE
ARTIST: Lynne Perrella

This is a collage consisting of eight cardstock shipping tags with toner transfers, plus paper batik techniques. Lynne likes to work in a series, and she enjoyed the challenge of using multiple images of the classic Velasquez portrait of Queen Marianne and changing the image on each tag, using different applications of dyes and batik techniques.

She made multiple toner copy prints of the portrait, and then used acetone to transfer the images to the smooth surface of the shipping tags. She likes to go for what she calls "hit and miss" results with transfers, and likes to splash the acetone onto the surface to get some "happy accidents." She used Procion MX dyes, made by Jacquard, to put down the first application of colors. Then she applied freeform designs of wax, using a Tjanting tool and white beeswax. When the wax dried, she added more applications of dyes. Each tag was placed between two sheets of plain newsprint, and a hot iron was used to melt the wax and create the batik effects in the dyes.

She recalled seeing the famous portrait of Queen Marianne at the Prado Museum during her first trip to Europe, and the image stayed with her. She liked the ceremonial aspect of the young girl's elaborate clothing and hair decorations; yet her youthful gaze is full of complicated pathos. Lynne found an image of the portrait in an old history of fashion textbook.

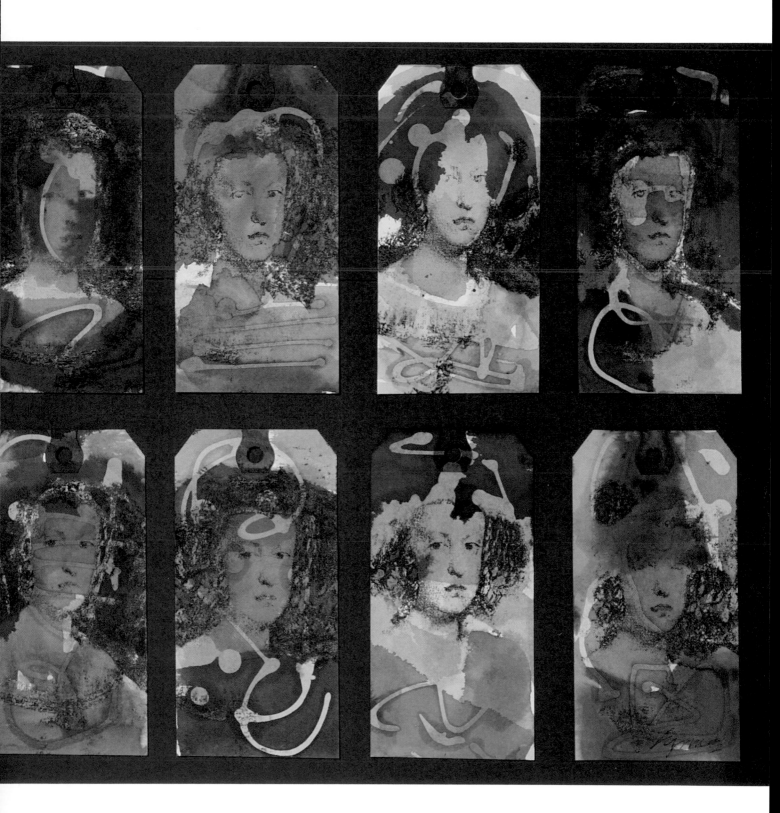

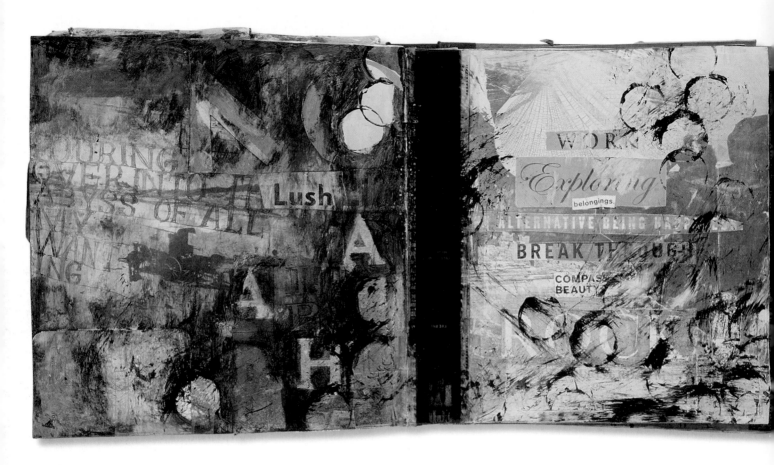

THE LOST NOTEBOOKS OF FISH & SHIPS 4/03–9/04
ARTIST: Juliana Coles

Juliana worked on this book mostly while teaching and was initially inspired by its square size and thickness. But the pages turned out to be very thin, and its bulk became intimidating. She started gluing two and three pages together and tearing out entire signatures. She would begin pages in one class, then work over them and begin again in another, and work over them again, and finish in another class. She uses her own work as backgrounds for note taking, as she did with this book at a James Hillman lecture where she got him to sign it. She has many autographs in what she calls her Extreme Visual Journals.

She often works on something for a long time—sometimes images can take years. Many times she paints over the whole thing. She is not attached to her imagery, but she is attached to telling her story, and sometimes she feels

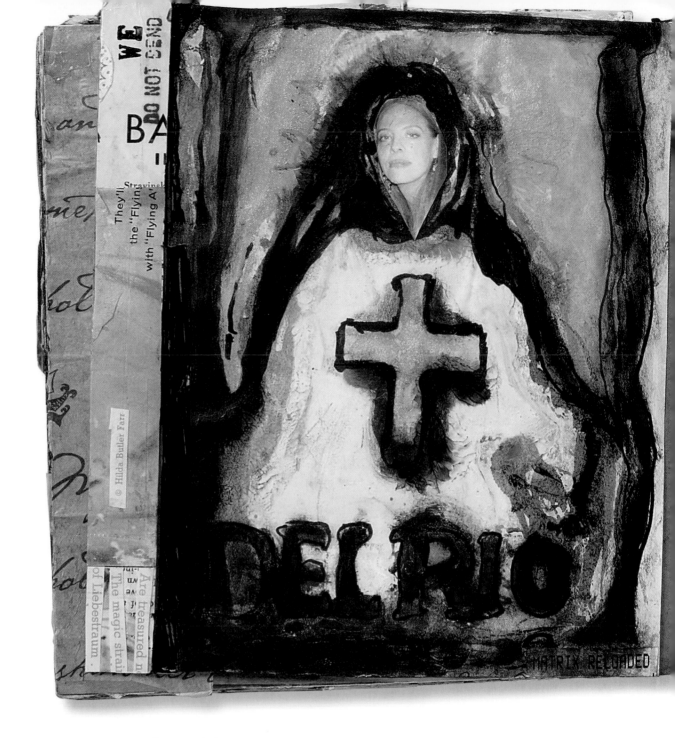

a story won't or can't be told. So she continues to work until it reveals itself. Many of the images in this book are from assignments she gives to her workshop students. She loves this book—how it feels in her hands, and the thickness of the pages—because she built all those layers.

Eventually she noticed the theme of "fish and ships," hence the title of the piece. The pages are not in chronological order because she moves around as she works. She feels that true expression is nonlinear. Juliana has been saving ephemera since she was a girl and enjoys seeing the evidence of herself 25 years ago. She loves altering images with tape. Mainly it's her own work she alters as she goes over and over it trying to find the story. It comes only through trial and error. She says she is not capable of working with preconceived notions; she is after something less tangible.

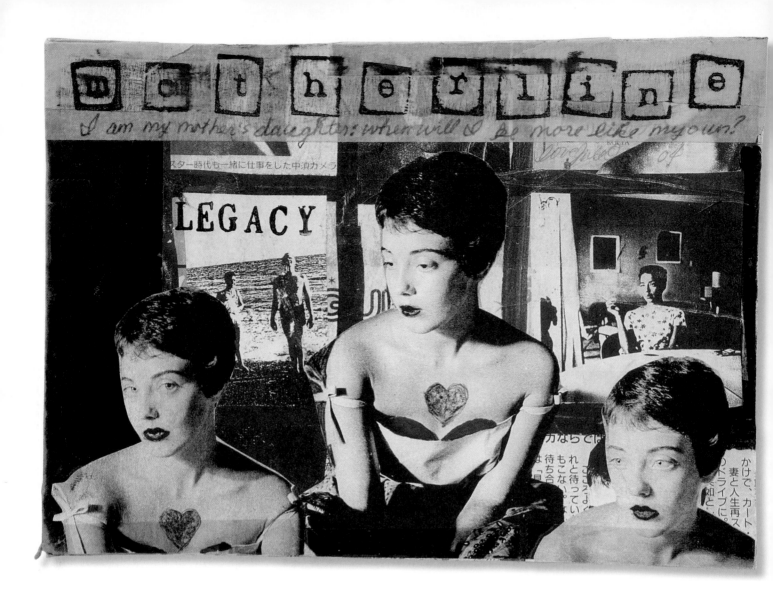

↑ Postcard from

POSTCARD BOOK #7
ARTIST: Juliana Coles

In her artwork, Juliana often uses a collection of photographs of her mother that her father took. Here, the background is a copy of another postcard. On the side is a slide of some of her artwork from a journal page. The card itself is cut from an old record album cover. She made a quilted piece from pictures of her parents with Asian newspaper. She copied it, cropped it, added the photographs of her mother, then added it to the background. She loves black and white, which is seen less often now that color machines are prevalent.

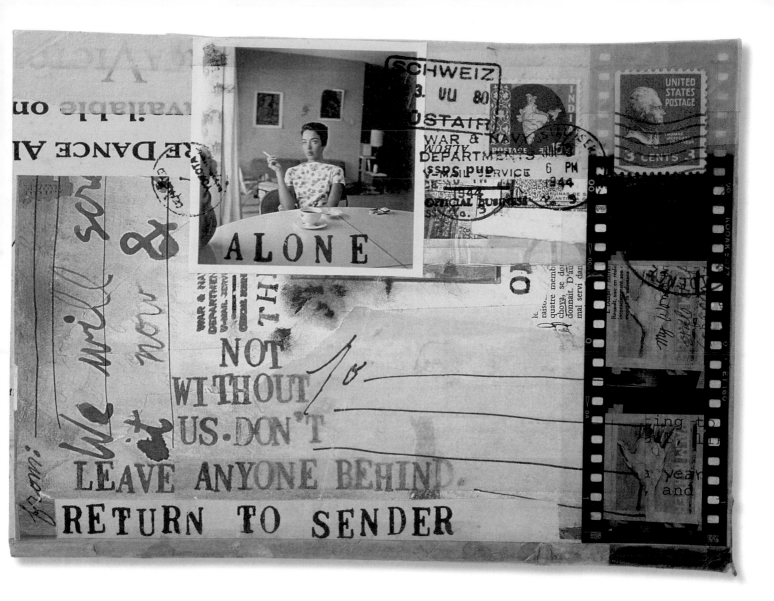

↑ Postcard back

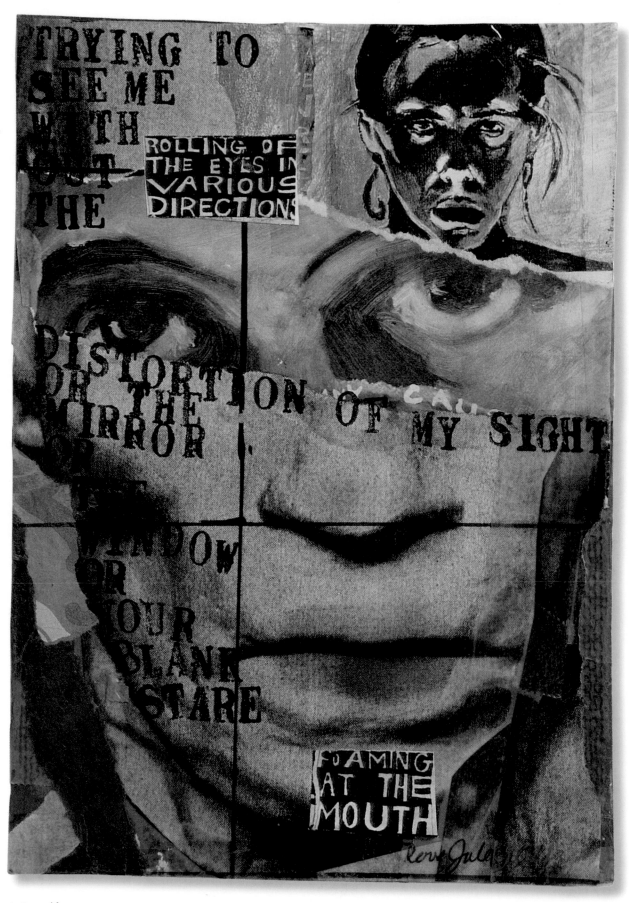

↑ Postcard front

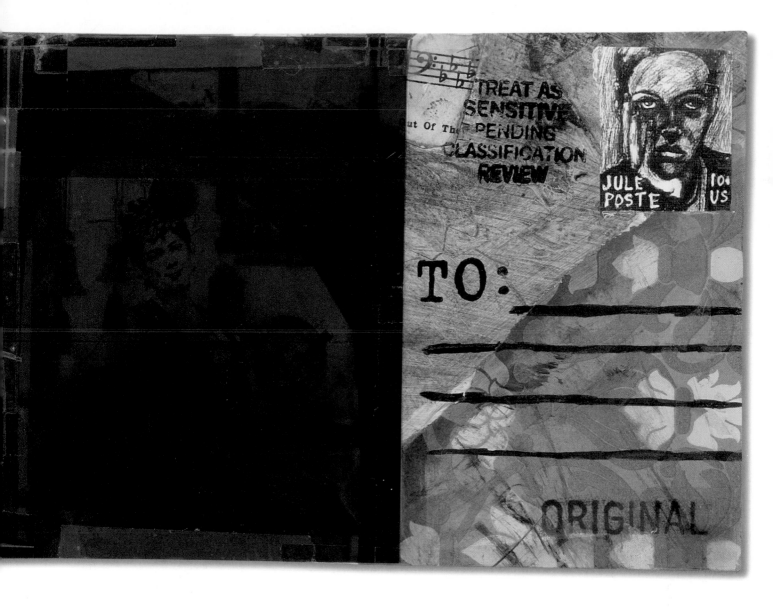

⬆ Postcard back

POSTCARD BOOK #2
ARTIST: Juliana Coles

The main face on the left is from a collage Juliana made for a painting class, approximately 3' x 3' (1 m x 1 m). She tore it up, glued it to a big board, added more details, and then cropped it into smaller pieces (about 5" x 7" [12.7 x 17.8 cm]). This is a technique she teaches her postcard class—decorating larger boards, then cropping them and continuing to add to them on top of these backgrounds. This face was enlarged from an image in a strange old book of bronzes of deceased people. The lines are the grid used to transfer the collage as you would a painting to a canvas. She used eyes from a former self-portrait. She took the copy of the torn eyes, tore it further, and glued them, a little askew, over the dead man's face. She then added a self-portrait at the top right. The little box of writing is from the same piece. Then with a stamp pad, she added lipstick and blush, continued the gridline into the torn eyes, and spontaneously added text. Milky tape was also added. The other side of the postcard is a transparency and another self-portrait from the same invitation turned into a postage stamp.

SCULPTURE WITH COLLAGE
ARTIST: Nina Bagley

This was a rare piece for the artist—its initial design unfolded entirely in her head before being created in its earthy, dimensional form. She had previously purchased a wonderfully worn, empty leather binoculars case at an antique store and imagined using it as some sort of altered container. The container hung in her studio, unadorned, unused, yet watchful. When asked to create a piece for this book, she says this case nodded and winked at her with insistence: her oldest son Robin had just left for his freshman year of college, and the bittersweet sadness of his leaving the nest still hovered about her as she worked in the studio. She decided to honor that maternal emotion and to honor him. A dear friend had given her the lovely rhododendron clippings on a visit to her mountain home, and the miniature "branches" lended themselves beautifully to a nest and tree theme. The binoculars case, now empty, had presumably once been used for spotting birds. The rest of this story tells itself.

For more than two years, Nina has worked with a transfer technique using ink-jet images and water. The process is instantly gratifying, easy, and inexpensive, and allows her to use her own photography for ethereal imagery. Going with the "empty nest" theme, she played with a photograph of their 1920s house (built, amazingly enough, by a woman named Nina—with its unusual long "i" like hers) in Photoshop, transferred it to watercolor paper, attached an egg image, and then affixed the simple "collage" to copper sheeting and covered it with a piece of mica and eyelets. She likes the fact that the photograph can be hung on the piece, or remove...for as we all know, the emptiness comes and goes.

Nina uses her own photography as a favorite source, because it has much more meaning and storyline than other subjects would convey. She also uses found images—people, houses, landscapes—for creating new stories.

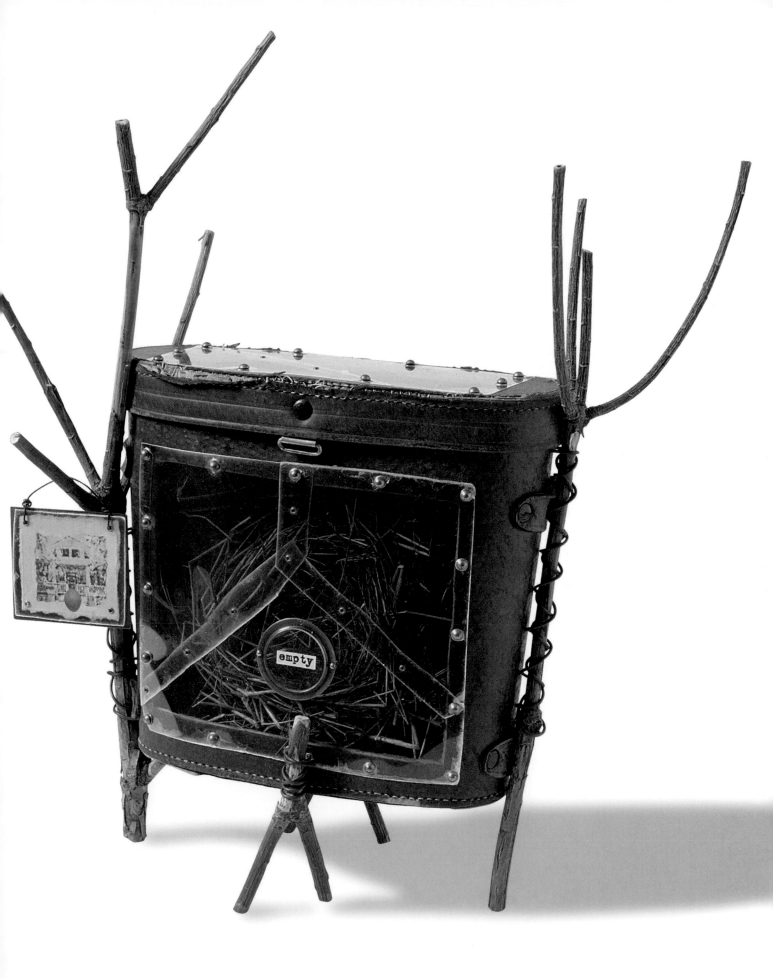

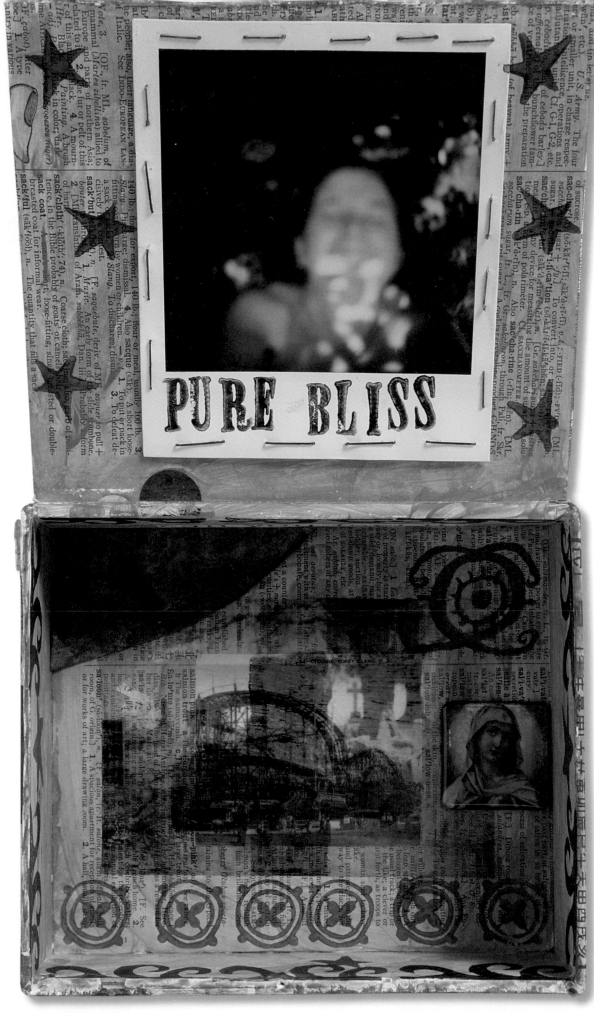

⬆ Art Box interior

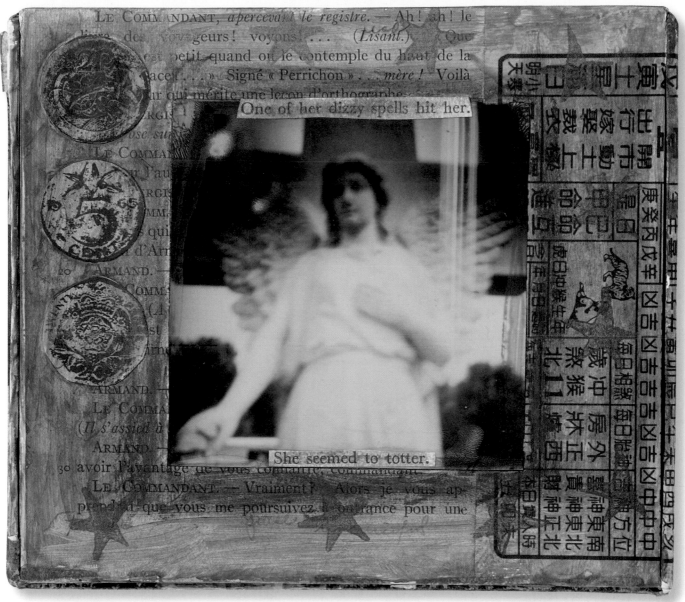

⬆ Art Box lid

ART BOX
ARTIST: Traci Bunkers

Traci decorated this cigar box to have a special box to store
her Polaroid photographs. She covered the inside and outside
with thin papers and then painted them. The photograph on
the outside is a pinhole photograph taken in a cemetery
using a modified old 600 Polaroid camera. After taking the
photo, she shook it to get the brown marks that add to the
dreamy quality. The self-portrait on the inside lid is also a
pinhole Polaroid image that shows how happy she is when
she's taking pictures. On the inside bottom is a transparency
that had been used for an ink-jet transfer on top of another
image to tone down the image. The stamps used are hand-
carved or from a line of art rubber stamps that the artist
designs and sells.

ARTIST'S TIP

*Here's a little trick I like to do
with Polaroid pictures: Right after
taking a picture, rapidly shake it.
You will get green or brown spots
that have a crackly, fingerprint
look to them. The spots happen
because the shaking during devel-
opment can make portions of the
film separate.*

VISUAL JOURNALS
Traci Bunkers

Traci works in her visual journals on a regular basis and is inspired or motivated by emotions and by events in her life, good or bad. It helps her find balance in her life as a single, self-employed artist. She works in existing books, usually leaving parts of the original page showing, but sometimes adding in completely new pages or totally covering the original page with gesso, paint, or collage material. She sees everything, the original page and images or notes to herself, as adding to the whole and creating a visual texture, including her handwriting.

She has a passion for toy and Polaroid cameras—anything that gives unusual or unexpected results. She loves the instant quality of the Polaroids and has modified several cameras to be pinhole cameras. To do that, she removes the lens and attaches a piece of aluminum from a soda can in which she pierced a small hole. She leaves the shutter and covers the electric eye (for auto exposure) with a piece of dark film to act as a filter. That tricks the electric eye and makes the shutter stay open long enough to expose the film through the pinhole.

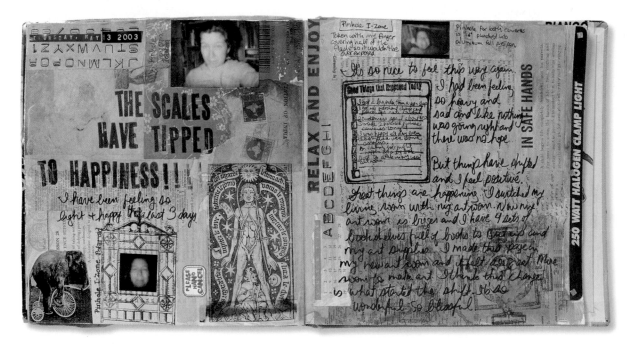

"AN ONGOING CONVERSATION WITH JULIANA COLES. . ."
ARTIST: Traci Bunkers

The artist was inspired to do this spread with the results from two new pinhole Polaroid cameras she had created from a JoyCam and an iZone. She completely covered the original page with pages from various old books and a map, then started collaging, stamping, and painting. The three self-portraits are all pinhole photographs, illustrating the blurry, not-so-real look that they evoke. On the far right is a piece of cardboard packaging attached with brads that were hammered flat. Smashing them down with a hammer tempers the newness.

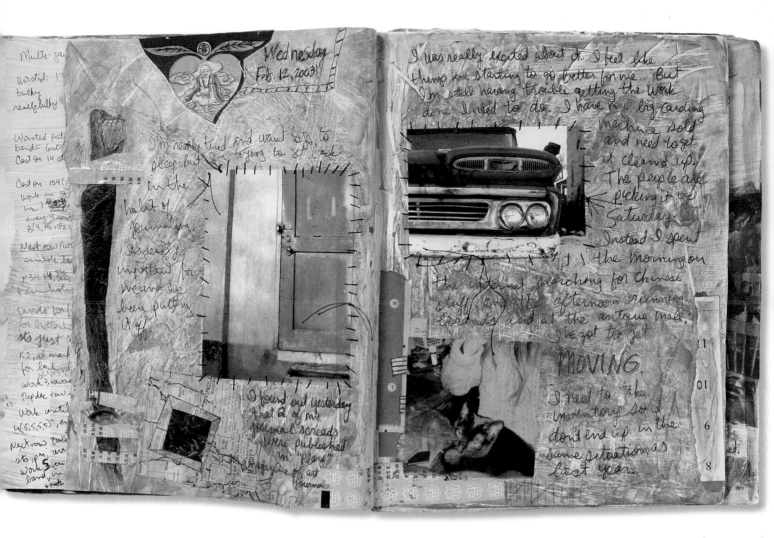

"IRELAND" JOURNAL
ARTIST: Traci Bunkers

The artist wanted to see what type of texture resulted if she glued down scrunched up, thin tissue paper. After gluing it down, she painted it and brayered it flat. Before the paint dried, she scraped it with an old credit card. The top two photographs were taken with a JamCam—a kid's low-tech toy digital camera that often gives surreal results. She sewed on those photographs to add to the textured background. The bottom-right photograph is a self-portrait taken with a Polaroid camera. When she took the photo, she shook it, which breaks up the internal chemical layers causing the marks and sometimes green or brown spots. It isn't as obvious on this photograph because she cut around it and removed the backing to make it a transparency. The places that are more transparent are where the chemical layers separated from the top layer.

ARTIST'S TIP

Be true to your inner bliss. When visually expressing yourself, just listen to the inner voice in your head, and you will hear the energy of the Divine. Express yourself uninhibitedly. The only trouble one may have during the creative process is the inner struggle between the conscious and subconscious mind—not knowing which one to follow. Listen closely and you will find the answer.

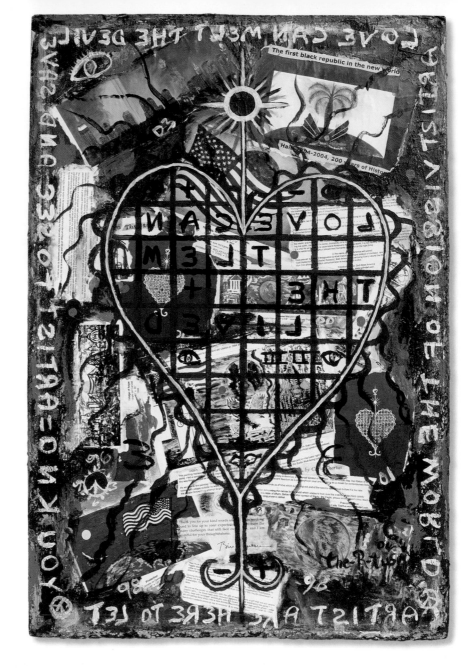

APOCALYPSE PAGE 2: LOVE CAN MELT THE DEVIL
ARTIST: Carlo Thertus

The inspiration behind this artist's work is concern for what he considers universal issues: that the human race must become more aware of the environment; that nature and world politics are both in a fragile state; that we must find harmony to exist; hand in hand; people of all races and religions must unite to save our planet and humanity; and that we have evolved to where we are today, the only species with the gift of imagination, intelligence, and knowledge. With our new wealth of knowledge we are taking baby steps into a new frontier. This piece, called "Apocalypse Page 2: Love Can Melt the Devil," is his further effort to help save the world.

Carlo cut and pasted photocopies of his artwork and painted on top of them, then finished the piece by writing around the edges of the collage. Carlo uses photographs and photocopies of his artwork for imagery.

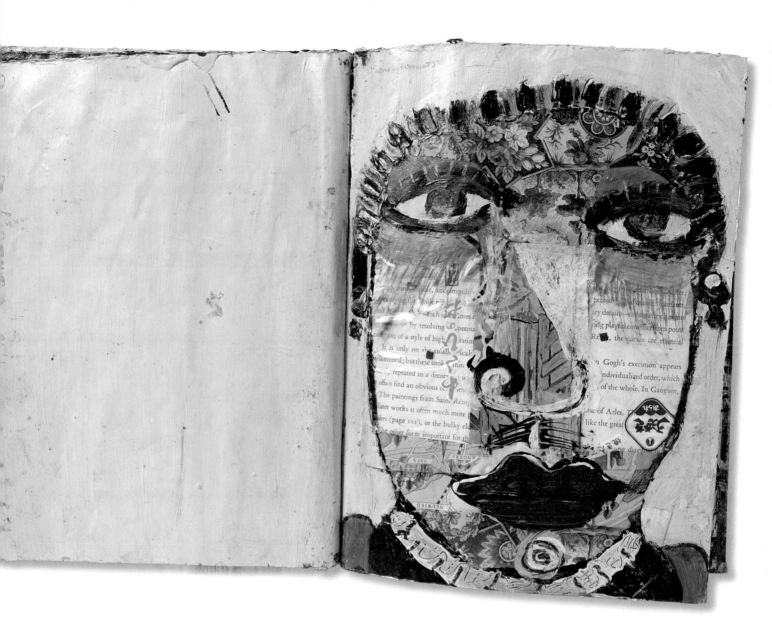

FEEL LIKE THIS, OR ANGOLA CENTEPEID #79
ARTIST: Anne Grgich

Anne's drawings and paintings are formed from spiritual loops and lines and poetry, a glimpse of her soul. She incorporates her dense inner life with the detritus of reality and ultimately fleshes out the demons, fights disassociation, and transforms pain to restore peace. For her, truth reveals itself in collage and paint and lends a sense of sanity in a fragmented life. The artwork flows out of an unconscious river leading to a sanctuary of certainty. Her books are a daily visual chronology, layered and meaty, and full of grisly realism and beauty.

RESOURCES

UNITED STATES

Adorama
www.adorama.com
photography supplies

Alternative Arts Productions
Box 3329
Renton, WA 98056
rubber stamps, collage sheets, publications, and more

Claudine Hellmuth
www.collageartist.com
unmounted rubberstamps

Dick Blick Art Materials
www.dickblick.com
800.723.2787
art and craft supplies

Green Pepper Press
P.O. Box 73
Piscataway, NJ 08855
Unmounted rubberstamps, book kits

Harbor Freight
www.harborfreight.com
aluminum foil tape, metal stamps

Home Depot
www.homedepot.com
aluminum tape, carpet tacks

Michael's
www.michaels.com
art and craft supplies

www.Ofoto.com
Upload your digital photographs and have them printed on photographic paper

Office Depot
www.officedepot.com
Binney & Smith Portfolio Series oil pastels (water soluble)

Pearl Paint
www.Pearlpaint.com
art and craft supplies

Portfolio Series Water-Soluble oil pastels
www.portfolioseries.com

Sacred Kitsch Studios
www.sacredkitschstudio.com
collage papers, rubberstamps, embellishments

Stampington & Company
www.stampington.com
rubber stamps, art supplies

Staples
www.staples.com
computer and printer supplies

Turtle Press
2215 NW Market Street
Seattle, WA 98107
www.turtlearts.com
book art supplies, rubber stamps

Utrecht Art Supplies
www.utrechtart.com
art supplies

Zettiology.com
P.O. Box 3329
Renton, WA 98056
www.zettiology.com
rubber stamps, collage sheets

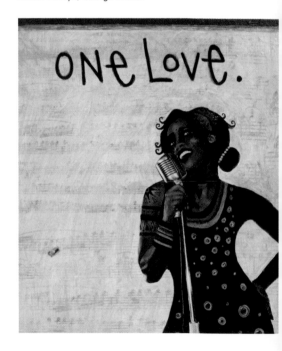

FLEA MARKETS

www.Sable.co.uk/fleamarkets/cities.asp
Locate flea markets across Europe

www.fleamarketguide.com
State-by-state listing of local markets in the United States

www.discoverfrance.net
Listings of France's best flea markets

www.darcity.nt.gov.au/markets/markets.htm
A small selection of some of Australia's best-loved markets

INTERNATIONAL

AUSTRALIA AND NEW ZEALAND

Bondi Road Art Supplies
179–181 Bondi Road
Bondi, NSW 2026
Australia
612.9387.3746
www.bondiroadart.com.au
pigments, paints, paper, books, inks, canvases, brushes

Eckersley's Arts, Crafts, and Imagination
1.300.657.766
www.eckersleys.com.au
Australia
art and craft supplies

CANADA

Curry's Art Store
800.268.2969
www.Currys.com
Ontario, Canada
art and craft supplies

Lazar Studiowerx Inc
www.Lazarstudiowerx.com
British Columbia, Canada
rubber stamps, art tools

EUROPE AND UNITED KINGDOM

Creative Crafts
11 The Square
Winchester
Hampshire SO23 9ES
United Kingdom
01962.856266
www.creativecrafts.co.uk
art and craft supplies

Graphigro
6e arrondissement
133, Rue De Rennes
Paris, France
0153.36000
www.graphigro.com
art supplies

Gilbert-Jean Booksellers
Lower Level
Left Bank
Paris
France
art supplies

HobbyCraft Group Limited
7 Enterprise Way
Aviation Park
Bournemouth International Airport
Christchurch
Dorset
BH23 6HG
United Kingdom
01202.596100
www.hobbycraft.co.uk
art and craft supplies

John Lewis
Oxford Street
London W1A 1EX
United Kingdom
01207.6297711
www.johnlewis.co.uk
art and craft supplies

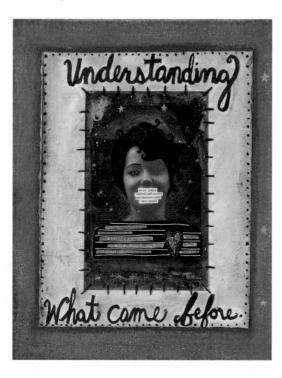

CONTRIBUTING ARTISTS

Nina Bagley
nina@ninabagley.com
www.ninabagley.com

Traci Bunkers
P.O. Box 442099
Lawrence, KS 66044
bonkers@bonkersfiber.com
www.bonkersfiber.com

Juliana Coles
meandpete@msn.com
www.meandpete.com

Shirley Ende-Saxe
rgrace44223@yahoo.com

Sarah Fishburn
sarah@sarahfishburn.com
www.sarahfishburn.com
www.cafeshops.com/sarahfishburn

Dana Gentile
gentile_dana@hotmail.com

Anne Marie Grgich
3800 Linden Avenue, N, Suite #3
Seattle, WA 98103
206.675.0816
angelica@annegrgich.com
www.annegrgich.com/

Claudine Hellmuth
chellmuth@aol.com
www.collageartist.com

Lynne Perrella
P.O. Box 194
Ancram, NY 12502
www.LKPerrella.com

Judi Riesch
jjriesch@aol.com
www.itsmysite.com/judiriesch

Lesley Riley
lesley@lalasland.com
www.LaLasLand.com

Lisa Renner
lisarenner@comcast.net

Monica Riffe
Fort Collins, CO
monriffe@hotmail.com

Carlo Thertus
carlo@gofindart.com
www.gofindart.com

Michelle Ward
P.O. Box 73
Piscataway, NJ 08855
grnpep@optonline.net
www.greenpepperpress.com

Lynn Whipple
jxlwhipple@aol.com
www.whippleart.com

Artist: Michelle Ward ➡

Even on dilapidated doors

BEYOND EVERY OBSTACLE

ABOUT THE AUTHOR

Karen Michel is a mixed-media artist who lives in New York where, with her husband Carlo Thertus, she runs a nonprofit visual art center for children called The Creative Art Space for Kids Foundation (www.caskfoundation.org).

Her books, paintings, and collages have been published in numerous books and exhibited throughout the United States as well as internationally. When not in her studio at the art center, Karen can be found teaching mixed-media art workshops throughout North America or feeding the pigeons in the park.

To view more of her work or to view her workshop schedule, visit www.karenmichel.com.

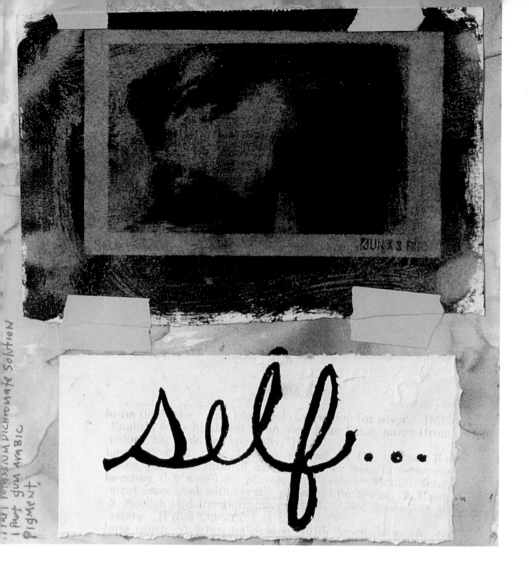

ARTIST STATEMENT

My passion for creating is an innate response to expressing and exploring my inner workings, my relation to my surroundings, and the search for truth that follows. Experiencing and portraying the spiritual and the physical, these images are intended to emanate a feeling of mindfulness and interbeing within ourselves and our surroundings. They are visual prayers, mantras. They are reminders to keep searching for the beauty and discovering the abundance that is within ourselves and our environment.

ACKNOWLEDGMENTS

I believe it all began when I was a child and my Aunt Norma handed me a pencil and helped me to "learn to see" in order to draw. This was followed by my mother allowing me to draw and paint on my bedroom walls and floor. Further on, it was my cousin Debbie and her husband James who made sure I went to art school, then back again to my mother who helped fill my fridge during my struggling student years. My biggest cheerleaders along the way, my sister Christine and my nephew Russell, both believe I can conquer the world.

To my niece Jeanine, who graciously helps around the art studio, to my nephew Gary, who is now following his own dream in the music world.

To all the artists I have met along the way who so openly shared their insights and knowledge on being a "working artist," serving as our own support group.

To all the incredibly talented contributing artists, who so generously shared their art for this book, and my editor Mary Ann Hall, who so patiently worked with me, new baby and all!

And last but not least, my biggest fan, my mentor, my husband, Carlo.

Thank you.